Portrait of Historic
Carlisle, Pennsylvania
and the Cumberland Valley

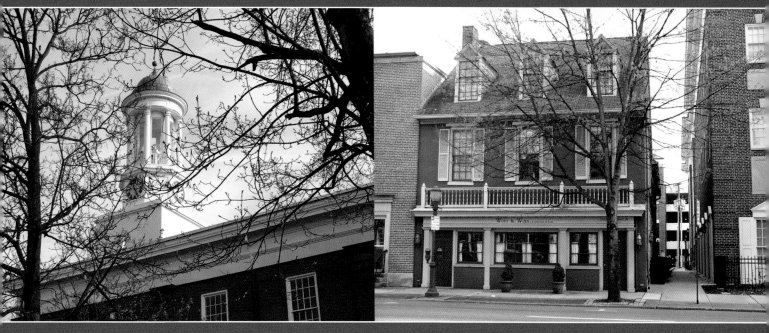

Clockhouse/cupola of the Cumberland County Courthouse, circa 1845.

Law office of Wolf & Wolf, 10 West High Street.

Stacy L. Breon

4880 Lower Valley Road • Atglen, PA 19310

Other Schiffer Books on Related Subjects:
Small Town Pennsylvania, 978-0-7643-4176-2, $34.99
Bucks County, Pennsylvania, 978-0-7643-4025-3, $29.99
Historic Architecture of Pennsylvania, 978-0-7643-4275-2, $34.99

Library of Congress Control Number: 2013932190

Type set in NewBaskerville BT

ISBN: 978-0-7643-4314-8
Printed in China

Published by Schiffer Publishing, Ltd.
4880 Lower Valley Road
Atglen, PA 19310
Phone: (610) 593-1777; Fax: (610) 593-2002
E-mail: Info@schifferbooks.com

For the largest selection of fine reference books on this and related subjects, please visit our website at:
www.schifferbooks.com.
You may also write for a free catalog.

This book may be purchased from the publisher.
Please try your bookstore first.

We are always looking for people to write books on new and related subjects. If you have an idea for a book, please contact us at:
proposals@schifferbooks.com.

Schiffer Books are available at special discounts for bulk purchases for sales promotions or premiums. Special editions, including personalized covers, corporate imprints, and excerpts can be created in large quantities for special needs. For more information contact the publisher.

In Europe, Schiffer books are distributed by
Bushwood Books
6 Marksbury Ave.
Kew Gardens
Surrey TW9 4JF England
Phone: 44 (0) 20 8392 8585; Fax: 44 (0) 20 8392 9876
E-mail: info@bushwoodbooks.co.uk
Website: www.bushwoodbooks.co.uk

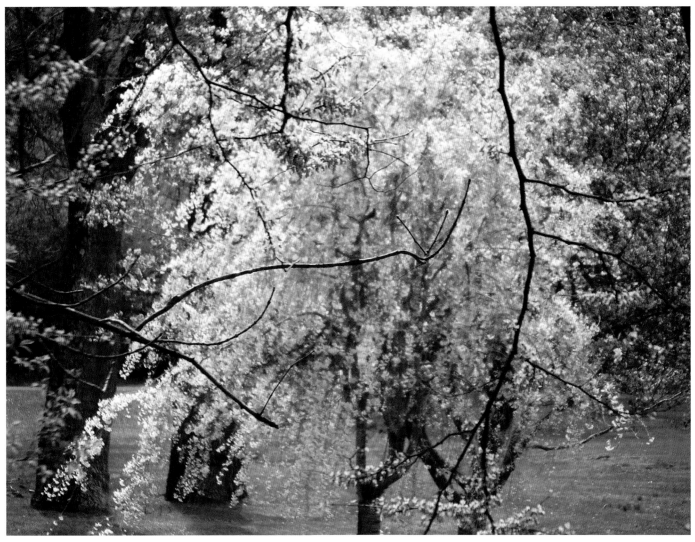

Spring trees blooming in Thornwald Park.

I dedicate this book in honor of my mother,
Shirley M. Knarr.

*I also dedicate this book in memory of: my father, Ronald E. Lebo;
my stepfather, Clair H. Knarr; and my paternal grandparents,
William Joseph and Elsie Stine Lebo.*

Acknowledgments

I am grateful to the historians who recorded information pertaining to all areas mentioned in this book, and my appreciation goes out to the homeowners and organizations for preserving the beautiful historic architectural homes and buildings in our valley.

I would like to express my deepest gratitude to the Cumberland County Historical Society and staff for retaining reference materials and making them easily accessible to those performing research at your facility.

Thank you to my mother, Shirley Knarr; husband, Tony Breon; and son, Cody Breon, for traveling with me to obtain photographs seen throughout this book. Gratefulness is also expressed to my sister, Kelli Wolf, and to my family and friends for their encouragement and information provided throughout the writing of this book.

To my employer, Foulkrod Ellis, thank you for the encouragement received to perform research and record historical information on your beautiful historic office building.

I would like to acknowledge and extend my heartfelt gratitude to family friend and retired English teacher, Joan Wolf, for spending many hours editing this publication.

Thank you to my 10th grade English teacher, Mr. Steven Ginter, for it was in your class that I first began to really enjoy writing. To my business teacher, Mrs. Ruby Baker, thank you for instilling in me such a great work ethic.

For inheriting their love of photography, writing, and recording of historical information, I would like to recognize my late grandparents, William Joseph Lebo and Elsie Stine Lebo.

Contents

Foreword

Welcome to my hometown. How did you first discover the charm of this quaint small town in South Central Pennsylvania? Maybe you first heard about Carlisle by attending one of the many car shows offered. Or maybe you came across this small town on your way to visit the nearby historic towns of Gettysburg, Lancaster, or Chambersburg. Or maybe you discovered this town when visiting Dickinson College or Dickinson School of Law as a potential college choice. Or maybe you were lucky enough to live here for a short period while being affiliated with the Army War College. Or maybe if you were really lucky, you discovered the charm of the Carlisle area in person while growing up here.

I was one of the really lucky ones having grown up in this area. However, it wasn't until I moved away for a year in the late 1980s that I realized how beautiful an area the Cumberland Valley was. There is so much to offer with Gettysburg, Hershey, Lancaster, and Harrisburg nearby, and larger metropolitan areas of Philadelphia, Pittsburgh, Baltimore, Washington, and New York City just a few hours away.

I still live in the Carlisle area, enjoying the architecture, gardens, and beautiful scenery of the valley and mountains. What has been the most fascinating to me is the history that surrounds the area of this small town, and the valleys in its midst.

The idea for this book came to life with a combination of the historical information I have collected over the years for a romance novel that I am writing, as well as believing a book like this would be welcomed by visitors and natives to the area. In addition to images of Carlisle's beautiful architecture and in-depth text of its history, I have also included some interesting facts I came across regarding how the Civil War affected our community. Hopefully this book will provide information on something not previously known, encouragement to discover the Carlisle area in person, and will draw you back to visit the area again and again.

Stacy L. Breon
January 2011

Hanging floral basket along High Street. Beautiful hanging baskets can be found throughout the downtown Carlisle area within a few blocks of the square. These baskets are planted locally at Ledgehill Greenhouse, a former employer to my mother. Yellow ribbons are tied to lamp posts to show support to our troops. American flags show patriotism throughout the summer. During the Christmas season, the streets are decorated with beautiful sparkling lights.

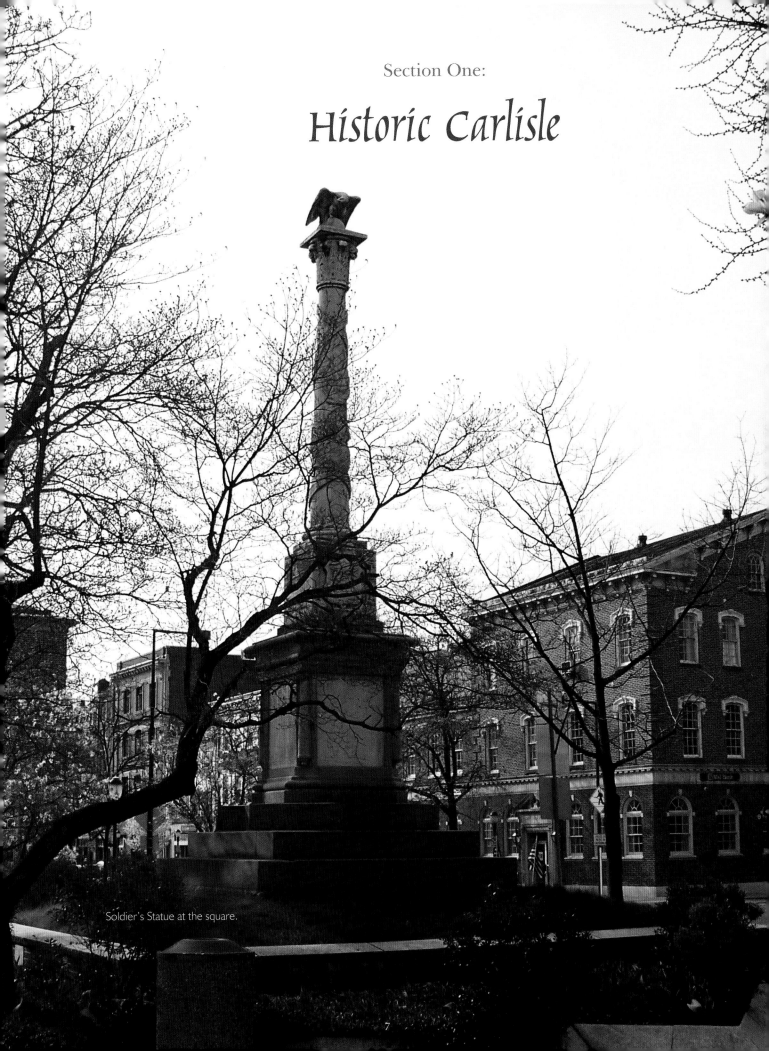

Section One:

Historic Carlisle

Soldier's Statue at the square.

History of Carlisle

Around 1749, approximately 4,000 Scotts-Irish immigrants of the Presbyterian faith left persecution and economic hardship in Ireland to accept William Penn's promise of economic opportunity and religious tolerance to settle in the Cumberland Valley. On January 27, 1750, carved from Lancaster County, the new Cumberland County had become the sixth proprietary county of Pennsylvania. Prior to European settlement, the Cumberland Valley was used by Native American Indians (the Susquehannocks, Shawnees, and Delawares). Five Indian paths converged on the site that was chosen for Carlisle.

The public square of Carlisle was deeded for public use by Thomas Penn, son of William Penn and a proprietor of Pennsylvania. Thomas Penn named the town after Carlisle, England, and he was involved in its planning. Martin Rupp, the County's noted early nineteenth century architect-contractor, had a hand in Carlisle's finer structures, which have since been demolished. The central square retains much of its early landscaping and streets lined with Victorian period architecture. The original town consisted of two blocks from the square, with the major streets being Hanover and High. The Historic District was established in 1976 with brown street signs to easily distinguish this section of town.

Carlisle was home to James Wilson, a noted lawyer and figure in the First Continental Congress. In 1776, he traveled to Philadelphia and participated in the signing of the Declaration of Independence.

The Borough of Carlisle was established in 1751. Carlisle is within the metropolitan region of the capital of Harrisburg, and is the County Seat of Cumberland County, Pennsylvania. This charming small community and historic college town is nestled between the North and South Mountains. Carlisle offers many shops, cafés, restaurants, theaters, and music and performing arts venues. The blocks surrounding the square in Downtown Carlisle are decorated in the summer with beautiful hanging baskets designed and made locally, with American Flags during patriotic holidays and, at Christmastime, decorative images displaying beautiful sparkling lights.

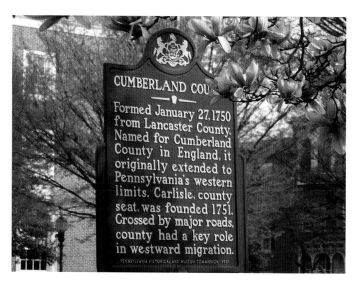

Cumberland County historic sign with magnolia tree blooms.

English and German settlers constituted about ten percent of the early population. The area was originally devoted mostly to farming, and was one of four locations considered for the county seat, including on the Susquehanna River, McClure's Gap, and Springfield. Shippensburg briefly served as the county seat of government until the courthouse was moved to Carlisle in 1751.

The area boasts connections to the Revolutionary War, the Whiskey Rebellion, the Civil War, Molly Pitcher, and Jim Thorpe.

Transportation was another important aspect of the Cumberland Valley. In the early years, Conestoga wagons and stagecoaches were utilized for travel. English visitor, Charles Dickens, traveled the turnpike road (now Carlisle Pike) on his tour of America in 1842. Every few miles along Walnut Bottom Road were taverns frequented by travelers as it was toll free. Taverns were licensed houses, where food, drink, and lodging were provided for a fee. The tavern saw its heyday in the 1820s, and by 1826, there were eighty-seven licensed taverns in Cumberland County. A toll was charged on Route 11, which had the greatest number of taverns. With the railroad's appearance

in the late 1830s came the closure of many taverns. The traditional tavern then began to evolve into the modern-day hotel.

In the eighteenth century, Americans consumed large amounts of alcoholic beverages. It was thought to be good for your health and a must at public sales, harvests, dances, weddings, and funerals. By the turn of the nineteenth century, the annual per capita consumption of distilled spirits was five gallons, three times today's level. Rum was the most popular since it was so inexpensive. Whiskey was popular with Scotts-Irish. Wine, brandy, and claret were also in demand. All taverns made punch with rum, white or brown sugar, water, and rinds and juice of lemons and limes. If a glass was broken, the patron was charged for it. The largest annual indoor celebration at taverns was to honor the birthday of George Washington. Another day celebrated, especially because of the Irish heritage in Carlisle, was St. Patrick's Day. Tavernkeepers were prohibited from serving minors, blacks, apprentices, or servants. Taverns also acted as local theaters, with actors traveling from town to town for performances. Taverns were also popular for dancing and music lessons, as well as functioning as medical centers, horse-breeding centers, and occasionally the scene of a coroner's inquest.

Natural spring spa resorts were very popular among America's well-off citizens in the mid-nineteenth century, and Carlisle was home to one of them. The Carlisle Springs Hotel in Carlisle Springs was at one time located on Route 34 between Routes 944 West and 944 East. This once-bustling resort town is currently a farming community. Today the only remnant from the former hotel is a marble basin from which the sulfur spring still spills. In 1858, local newspapers reported that the 200-room resort was the most popular in the north and was noted to offer a tip-top supper. It was also known as a place to relax, escape the heat and noise of the city, and to take in the waters. The surrounding mountains afforded sportsmen a great variety and plenty of game. The sulphur springs were highly recommended by medical experts at that time. In its heyday, the Carlisle Springs Hotel was a popular day destination for Dickinson College students and cavalry officers stationed at the Carlisle Barracks. An orchestra played three nights a week in the large ballroom, and dances were held on the lawn with guests from Carlisle and the surrounding region. In 1859, a grand ball with entertainment and fireworks was held here. The hotel was reached by taking a train to Carlisle, and then horse and buggy to the hotel. Its trade declined during and after the Civil War. The grand four-story structure was built entirely of wood with doors from each room opening onto porches on all sides, topped by a cupola where a flag flew. It unfortunately burned to the ground in February 1869.

The Cumberland Valley Railroad from Harrisburg to Chambersburg was opened for travel in 1837. The first sleeping car in the world was used on this railroad during the winter of 1836-37. The railroad was extended to Hagerstown, Maryland, in 1859, just in time to play an important role in moving troops and supplies during the Civil War. The Confederates tried to destroy the bridges that supported the Cumberland Valley Railroad at least three times.

In the early 1900s, the Newville-Carlisle Trolley tracks ran along what is now Route 641. Families would take the trolley to the (no longer existing) Newville Park (one mile east of Newville) to picnics, to band concerts, and to the dance pavilion.

The Conodoguinet Creek runs from Horse Valley in Franklin County, through Cumberland County, and joins the Susquehanna River near Harrisburg. Many Native American towns were at one time located on the banks of this creek. In 1840, the creek provided power for more than 140 mills throughout the county. Today anglers enjoy fishing and boating in the creek.

Education has always been an important aspect of Carlisle, and the town was the location of the first public school opened in Pennsylvania. It is also home to the U.S. Army War College, Dickinson College, and the prestigious Dickinson School of Law. At one time, the Carlisle Indian Industrial School and Carlisle Commercial College were also located here.

The history of Cumberland County is evident with preservation in Carlisle, Mechanicsburg, Newville, and Shippensburg. Locations include the Mechanicsburg Museum Association, the U.S. Army Heritage and Education Center, the Cumberland County Historical Society, Newville Historical Society, and Shippensburg Historical Society. Military institutions remain prevalent to the area with the New Cumberland Army Depot, Mechanicsburg Navy Depot, Letterkenny Army Depot, Fort Indiantown Gap, and the U.S. Army War College.

The area offers a very affordable lifestyle and below-average cost of living. It combines both rural and urban lifestyles to suit each individual's needs and desires. Carlisle was designated a Tree City, USA, by (former) First Lady Laura Bush as the second community in Pennsylvania to become a "Preserve America" community, and was ranked third in the 2008 MSN Real Estate Most-Livable Bargain Markets.

Since September 1974, the Carlisle Fairgrounds has hosted numerous car shows each summer, attracting people from all over the world. This is the location for the largest collector car events in the country.

Numerous events also occur in Downtown Carlisle, including a New Year's Eve celebration, Summerfest the week of July 4th, and Octoberfest in the fall.

The Appalachian Trail is 2,178 miles long from Maine to Georgia, with the midway point running through Pine Grove Furnace State Park, just outside of Carlisle. The nearby town of Boiling Springs has been designated as the tenth Appalachian Trail Community.

For a unique experience, visit Meadowbrooke Gourds between Carlisle and Newville. This business has been featured on the television show *Dirty Jobs*.

The Civil War in Carlisle

Throughout the countryside villages and towns in the area, the Civil War affected soldiers, civilians, men, women, and children. Some women helped to nurse tens of thousands of wounded soldiers.

When intelligence was received in late June 1863 of the defeat of Milroy at Winchester, measures of precaution were taken by merchants who packed their goods and sent them to eastern cities. It became evident the states of Maryland and Pennsylvania were to be made the battlefields, and many area citizens decided to leave town. Some started on foot for Harrisburg and other points. A number of citizens from the upper end of the county stopped in or near Carlisle with their stock. They were soon hurrying on their way, greatly increasing alarm and confusion that the Rebels were approaching. The next day was quiet with no Rebels nearby. The next morning, the Rebels were said to have been within a few miles of the town, but the people had heard too many scares and were exhausted with rumors and reports. They were unwilling to give credence to the "cry of wolf" when it was reality. The people could scarcely believe the Rebels were within a quarter-mile of town when Union Captain Boyd's cavalry announced it. At eleven o'clock Saturday morning, the Rebel advance entered the town, about four hundred in number, each carrying guns in a position to use in an instant. General Jenkins demanded 1,500 rations be furnished within one hour. In less than an hour, the market house was piled with eatables.

By June 24, 1863, Confederate Brigadier General Albert Gallatin Jenkins was roaming the Carlisle area, playfully capturing Sheriff Thomas Rippey's hat, but releasing him. On the morning of June 27, 1863, Jenkins rode up High Street, past the Carlisle Market and jail, and out of town. By nightfall, 12,000 armed Union soldiers were spread in and around Carlisle as far as Hickorytown.

Confederate General Richard S. Ewell reached Carlisle, trailing an armada of 3,000 captured cows and supply wagons with 50,000 barrels of seized flour. He passed through town and went to the Carlisle Barracks, where he established headquarters. He demanded supplies, medicine, amputating instruments, and 1,500 barrels of flour, of which each were beyond the capacity to supply. Rebels threatened to search stores and dwellings if not supplied. Having failed to meet the requisitions, squads of soldiers commenced searches Sunday morning and took any items needed from stores and warehouses. On Monday, citizens were relieved when an order came through for the force to leave. For two days, all communication with Harrisburg was cut off, and anxiety was felt by all upon learning what was transpiring on the south side of the mountain.

By Wednesday, Union Captain Boyd and Union troops arrived in town hungry. Again, within minutes, citizens filled the Market House with eatables. During the day, regiment after regiment arrived and took position on the public square and along Hanover Street. At half past six o'clock, Union General Smith arrived. A Rebel officer entered town with a flag of truce to inform General Smith of General Lee's command of 3,000 cavalry demanding surrender of the town. General Smith refused and the Rebel informed him that shelling would proceed. There was a scene of confusion with terrorized families rushing from their houses, mothers carrying babies while little ones clung around them weeping and moaning. The sick, scarcely able to walk, were helped by friends trudging towards the open country north of town. The streets were crowded with those fleeing with the second shelling. Women and children ran into cellars while those who fled to the country waited in the mud and wet through a long terrible night.

The Rebels fired on a board yard (lumber yard) near the gas works, and flames were leaping up in the sky. A stable and dwelling connected to the yard were also enveloped in flames. People on the eastern section of town fled their dwellings amidst the rain and hurried into the fields. At ten o'clock on July 1, 1863, the torch was applied by the Confederates to the Barracks. When the scene of fire was the grandest, the artillery ceased. A flag of truce bearer proceeded to General Smith's headquarters and renewed his demand for surrender. A third shelling commenced. When the Rebels received word from Robert E. Lee to cease operations, they left by way of Boiling Springs Road to Papertown and across the mountain towards Gettysburg, closing this momentous incident in Carlisle. The order from Lee spared Carlisle from further destruction. It is believed that one Union soldier suffered a mortal wound during

the Carlisle event. Scars from the shelling are visible on the sandstone pillars of the Old Courthouse at the Square. It is interesting that Dickinson College was represented by student soldiers on both sides of the Civil War.

Historical Figures/Celebrities

Many historical figures at one time lived in or traveled through Carlisle and the Cumberland Valley area.

JACQUES LE TORT was an early and prominent Native American interpreter that received a license to trade with the Shawnees in 1712. LeTort established a trading post along what is now known as the LeTort Stream.

In 1753, BENJAMIN FRANKLIN negotiated a treaty with Native Americans in Carlisle. The Shawnee Indians were angry at white settlers along the Conodoguinet Creek.

In 1756, GENERAL JOHN ARMSTRONG marched from Carlisle on the successful Kittanning Expedition against Native Americans. He is buried in the Old Graveyard.

In 1775, local men enlisted and marched four hundred miles to Boston to support Massachussetts in the Boston Tea Party. On May 23, 1776, signers of the Declaration of Independence included JAMES WILSON and JAMES SMITH of Carlisle, as well as Cumberland County lawyer, GEORGE ROSS. James Wilson was one of six to sign both the Declaration of Independence and U.S. Constitution.

MARY HAYS McCAULEY is believed to have taken her husband's place at the cannon after he was wounded in the Battle of Monmouth on June 28, 1778. She earned her nickname "Molly Pitcher" from taking water to wounded soldiers. A statue marks her tomb in the Old Graveyard.

PRESIDENT GEORGE WASHINGTON visited Carlisle in October 1794 on his march to southwestern Pennsylvania to put down the Whiskey Rebellion. The rebellion nearly resulted in a civil war over the unpopular excise tax on whiskey, but the presence of the President helped to diffuse the crisis.

JAMES BUCHANAN was born in Mercersburg, Pennsylvania, in 1791, graduated from Dickinson College in 1809, and was the 15th President of the United States from 1857-1861.

JAMES HAMILTON was one of the first promoters of America's Common School System. Carlisle High School was the first public school in Pennsylvania based on a July 4, 1836 resolution. It had the first public library in a high school. When Hamilton died in 1873, he bequeathed property and funds for the founding of the Hamilton Library Association, now the Cumberland County Historical Society. He is buried in the Old Graveyard.

Civil War Generals JEB STUART and FITZHUGH LEE were part of the shelling of Carlisle on July 1, 1863. A painting depicting this event is in the Metropolitan Museum of Art.

BESSIE JONES was a third-generation madam in Carlisle. Her grandmother came to Carlisle from the South during the Civil War and started her prostitution business that remained in Carlisle, as well as the family, for more than one hundred years. Bessie was murdered in 1972 in her Carlisle home; the murder is still unsolved today. Although Georgia Ann Schneider was charged with the murder, she was found not guilty by a jury.

DANIEL DRAWBAUGH applied for a telephone patent in 1880. It was reported that Alexander Graham Bell learned of Drawbaugh's work through a spy that stole the plans and sold them to Bell.

A local sports legend was JIM THORPE. Born in 1887, he was winner of the Pentathlon and was a five-event, all-around athlete champion of the world at the Olympic Games in Stockholm, Sweden, in July 1912. He became the only athlete ever to win gold medals in both the pentathlon and decathlon. He attended the Carlisle Indian Industrial School where he played football. He also played baseball for the New York Giants and played for several teams that became part of the National Football League. The NFL named its Most Valuable Player award after Jim Thorpe. In August 1951, the movie, *Jim Thorpe, All American*, premiered in Carlisle.

LOUIS TEWAMINA was a distance runner who won trophies at the 1908 and 1912 Olympic Games. A parade for the Olympic heroes was held in Carlisle for Tewamina and Jim Thorpe on August 16, 1912. They both attended the Carlisle Indian Industrial School.

GENERAL DWIGHT D. EISENHOWER was greeted by 10,000 citizens in May 1947 on his way through Carlisle to address the graduating class at Carlisle Barracks.

Eisenhower was in the Class of 1928 at the U.S. Army War College, he was a five-star general, and the 34th President of the United States.

General H. Norman Schwarzkopf, Gulf War general, graduated from the U.S. Military Academy in 1956 and later attended the U.S. Army War College in 1973.

President George W. Bush visited the U.S. Army War College in May 2004 and December 2008.

The Carlisle High School basketball team won the State Championship four consecutive years, 1985-1988. Led by Coach Dave Lebo, key players were Jeff Lebo and Billy Owens. Jeff Lebo continued his basketball career at the University of North Carolina and is currently a college basketball coach. Owens continued his basketball career at Syracuse University, became a professional player in the NBA, and is currently a college basketball coach.

Mt. Holly Springs is the hometown of Sid Bream, who played baseball for the Los Angeles Dodgers, Pittsburgh Pirates, Atlanta Braves, and Houston Astros. He had a famous slide into home plate, scoring the winning run that put the Atlanta Braves into the 1992 World Series. Evan Englebrook, a Cumberland Valley graduate and Shippensburg University alumnus, is a current Houston Astros pitcher.

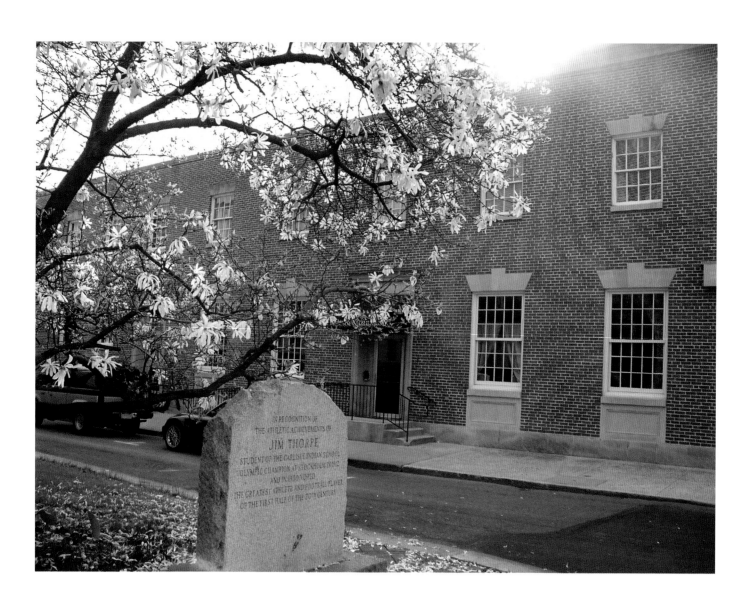

Carlisle Area Architecture

The beautiful architecture of Carlisle buildings and homes include variations of Federal, Colonial Georgian, Romanesque Revival, Classic Greek Revival, Italianate, and Victorian styles. Architecture in our small town even includes a replica of the Norman Castle in Carlisle, England, as well as a building designed by the same architect who did the U.S. Capitol. The Metropolitan Museum of Art now displays two Robert Welford-designed mantels that were once in a Carlisle house.

First Presbyterian Church

Located on the northwest corner of High and Hanover Streets, this native limestone Colonial Georgian is the oldest public building remaining in Carlisle. The church got its start at Meeting House Springs in 1734, a few miles from the current site.

Construction at its present site began in 1757, but was delayed until 1766 when a permanent deed was secured from the Penn family. It was designed by Robert Smith, a Philadelphia architect, and was used for public meetings and religious worship. Colonists met here in 1774 to declare independence. On May 23, 1776, James Wilson, James Smith, and George Ross were local signers of the Declaration of Independence. During church, rifles were often placed against the pulpit in case they were needed in the event of an Indian attack.

President George Washington attended Sunday services here on October 5, 1794.

The entrance originally faced West High Street, but was altered in 1827.

St. John's Episcopal Church

Situated on the northeast corner of St. James Square, this building was erected circa 1826 with stones from an earlier church that dated back to the 1760s. It was remodeled in 1861 in the Romanesque Revival style, with expansions in 1986.

Since the time of the founding of Carlisle in 1751, the northeast corner of the square was reserved by the Penn family for the "English Church." A rustic log building served temporarily as both the courthouse and church. In 1762, the log structure was replaced with a modest stone colonial church. Work on the present church began in 1826.

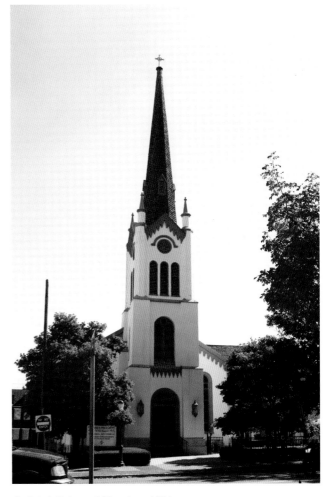

St. John's Episcopal Church, c. 1826.

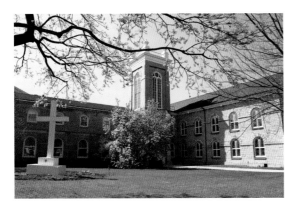

First Presbyterian Church, c. 1766.

The New Courthouse

Situated on the southeast corner of South Hanover and East High Streets, this was the former site of the beautiful old Brick Market House built in 1878. Market was held twice weekly in the Victorian Eclectic style structure until it was demolished in 1952 following a Pennsylvania Supreme Court battle for the New Courthouse. Construction of the New Courthouse ended Thomas Penn's original intentions for the southeast corner of the St. James Square to serve as a market.

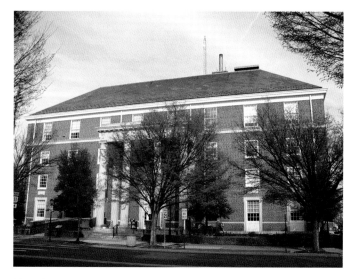

New Courthouse, c. 1952.

The Old Courthouse

Located at the southwest corner of the square, this Classic Greek Revival red-brick structure was built 1845-1846. The façade is supported by sandstone fluted columns and an impressive bell-and-clock tower with Classic Revival ornamentation. This is an early example of a fireproof building with brick construction and thick walls. The original courtroom on the second floor was restored in 1991.

Previously on this corner was a wooden structure built around 1766; this was destroyed by fire on March 27, 1845. On this site was the first public library in the United States. Important meetings here included support for the French Revolution 1791-1793, promotion of peace during the War of 1812, and Friends of Education to draft a public school system in 1836.

The second column from the left bears the mark of Confederate artillery barrage, and a scar is also on the lower left windowsill. On July 1, 1863, General Robert E. Lee ordered the Confederate cavalry unit to the Battle of Gettysburg, sparing further damage to the town.

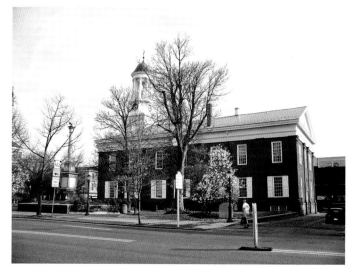

Old Courthouse, c. 1845.

Column of Old Courthouse with the scar received from Confederate artillery barrage on July 1, 1863.

St. James Square

The first block of East High Street was at one time known as St. James Square. It was named after St. James Square in London, England. In the 1800s, this was a prestigious residential block within which many attorneys and judges lived.

The alley beside St. John's Episcopal Church is known as Irvine Row. These buildings were here in 1845, and were at one time homes to law offices.

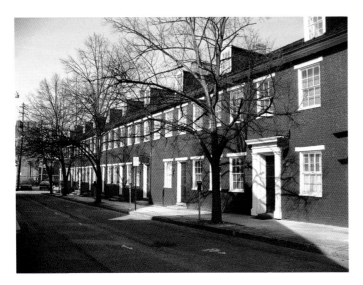

Irvine Row, c. 1845.

THE OLD COUNTY JAIL, at 99 East High Street, was built in 1854 as a replica of Norman Castle in Carlisle, England. It replaced an earlier jail built in 1745. The iron fence once surrounded the old courthouse and was made locally. The prison limestone wall was built in 1813. The prison was retired in 1984 when a larger prison was built in a new location outside of town. The Old County Jail now serves as housing for local county offices. Incarcerated here in the 1800s was David Lewis (Lewis the Robber), known for robbing the rich and giving to the poor. In the mid-1900s, Bessie Jones, a third-generation Carlisle madam, was incarcerated here on several occasions for tax evasion. A book was written on the story behind Bessie Jones called *Bessie's House*, by Paul Zdinak.

THE WELLINGTON, 17 E. High Street, was known as one of Carlisle's finest hotels. In 1986, it was restored to its 1890s Victorian appearance. Taverns and hotels have occupied this site since 1815. Portions of the stone tavern from the 1800s can be seen from the rear alley.

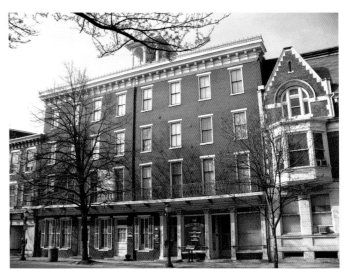

The Wellington, c. 1890.

THE DUNCAN-STILES HOUSE, 52 E. High Street, was built circa 1815 for Stephen Duncan and his bride, Margaretta Stiles, by his father, Chief Justice Thomas Duncan. The Federal style home includes an oval-shaped living room with curved walls, windows, and doors. The curved walls allowed closets to be tucked into corners of the room. Two Robert Welford-designed mantels from this house are now housed in the Metropolitan Museum of Art.

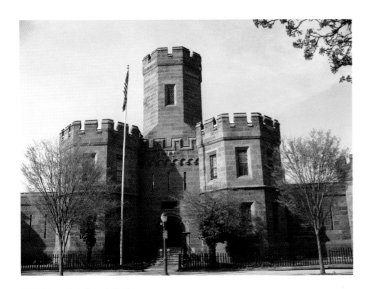

Old County Jail, c. 1854.

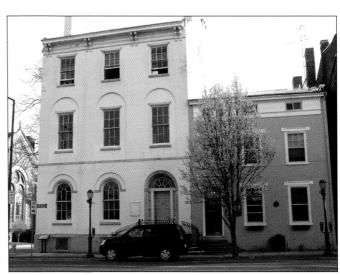

Duncan-Stiles house, c. 1815.

First Evangelical Lutheran Church, 100 E. High Street, was built in 1901. The Romanesque Revival church was designed after cathedrals in Italy. The Lutherans were organized in Carlisle in 1766. In the 1770s, this site was the home of early Carlisle physician and Revolutionary War Officer, General William Irvine. Mary Hayes (otherwise known as Molly Pitcher) worked in Dr. Irvine's home.

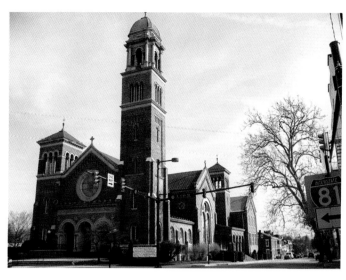

First Evangelical Lutheran Church, c. 1901.

Irvine Plantation, 200 block of E. High Street at the corner of East Street; it was built circa 1810 with three later additions. It was also known as The Stone House Inn. East Street marked the scrimmage line between the Union and Confederate soldiers during the Confederate invasion of Carlisle in 1863.

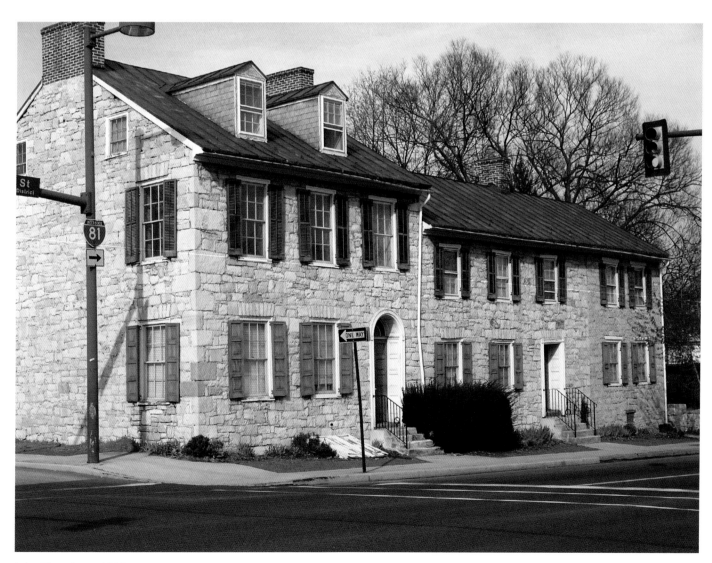

Irvine Plantation, c. 1810.

GIVIN BANK, 1 West High Street: In 1865, this building was erected by Robert Givin with The Farmers Trust on the first floor and his home on the second and third floors. Givin was the bank's first president. His daughter, Amelia, ran the Mount Holly Springs Paper Company. Upon the death of Amelia's mother in 1887, she inherited $10 million. Amelia erected the public library in Mount Holly Springs in 1889 and lived in the upper floors of the bank until her death in 1915.

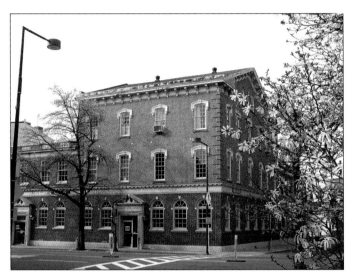

Givin Bank, c. 1865.

AMELIA S. GIVIN LIBRARY, just south of Carlisle on Route 34 in Mount Holly Springs, is located at 114 N. Baltimore Avenue. This beautiful 1890 brownstone was designed using classic Richardsonian elements with interior reinterpreted Victorian ornamentation. It was the first free public library in Cumberland County. In 2004, it was added to the National Register of Historic Places. Previously on this site stood The Central Hotel, a luxury hotel that was built in 1876 and destroyed by fire in 1888.

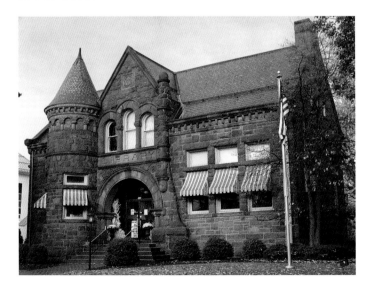

Amelia S. Givin Library, Mount Holly Springs, c. 1890.

HISTORY ON HIGH – THE SHOP, 33 West High Street: The building dates to 1858 and has been owned by the Cumberland County Historical Society since 2004, first opening for business in 2008. The store specializes in items from the county's past and offers items ranging from books to jewelry. The Cumberland Valley Visitors Bureau has also been located here since 2011.

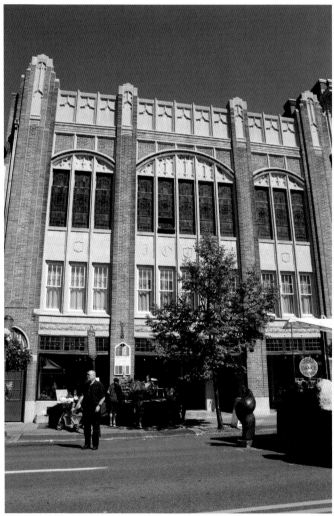

History on High Shop, c. 1858.

Cumberland County Historical Society, 21 N. Pitt Street: The building was constructed in 1881 in the Victorian Italianate style. The historical society was founded in 1874 from a bequest of property and funds by James Hamilton. With over 37,000 visitors annually, it offers an award-winning museum, educational programs, the Hamilton Library, and materials from the Carlisle Indian Industrial School.

Now a parking lot to the Historical Society, 45 West High Street was at one time the home of James Hamilton. In 1905, John Pishotta purchased it to use as a store, from which he would sell fruit and candy. On April 13, 1909, Pishotta was murdered here by his wife Annie and her brother Angelo Tornatore. His body was discovered in the wine cellar. The house was later demolished, and the Orpheum Theatre was eventually built on this site — it stood for three decades before being destroyed by fire.

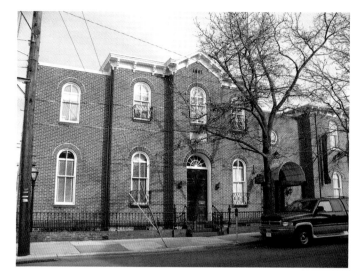

Cumberland County Historical Society, c. 1881.

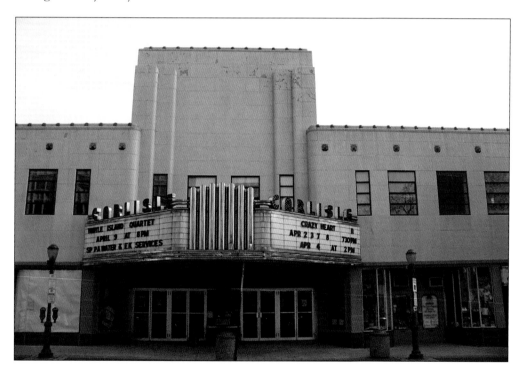

Carlisle Theatre, c. 1939.

Carlisle Theatre, 44 High Street: Jim Thorpe was a featured guest here at the movie premiere of *Jim Thorpe-All American*. The 1939 theater has been restored. In the mid-1800s, this site was the home of the second Secretary to the Smithsonian Institution, Spencer Fullerton Baird.

Centenary Church, southeast corner of West High and South Pitt Streets: The former church was built in 1876 by the Methodist Church. The corner was previously occupied by the German Reformed Church. It was later converted into apartments and stores. A fire in December 1999 gutted the building. It has since been restored.

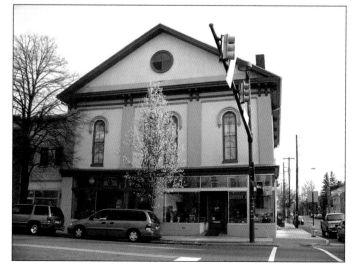

Centenary Church, c. 1876.

THE WILSON HOUSE, southwest corner of West High and South Pitt Streets: The home of James Wilson, a signer of the Declaration of Independence, was located at this site. Wilson immigrated from Scotland to the colonies in 1765. George Washington appointed him an Associate Justice of the Supreme Court. This site included various hotels, including Pollock's Tavern, where the founder of Dickinson College, Dr. Benjamin Rush, was a guest in 1784.

Across the street from Wilson House is where the Cumberland Valley Railroad Station was once located. It was founded in 1836. The train ran through the middle of town with the last passenger train in 1936. The railroad building was demolished with the blue limestones being recycled into an apartment building on West South Street.

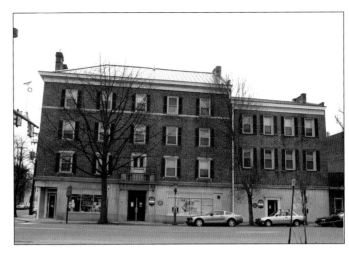

Wilson House. This site was once the home to James Wilson, a signer of the Declaration of Independence.

BELLAIRE HOUSE, 141 West High Street: Originally an earlier Federal style, the house was remodeled in the 1830s in the Greek Revival style. The marble steps of this house were in the opening scene of a 1906 Civil War romance novel by Mary Dillon, *In Old Bellaire*.

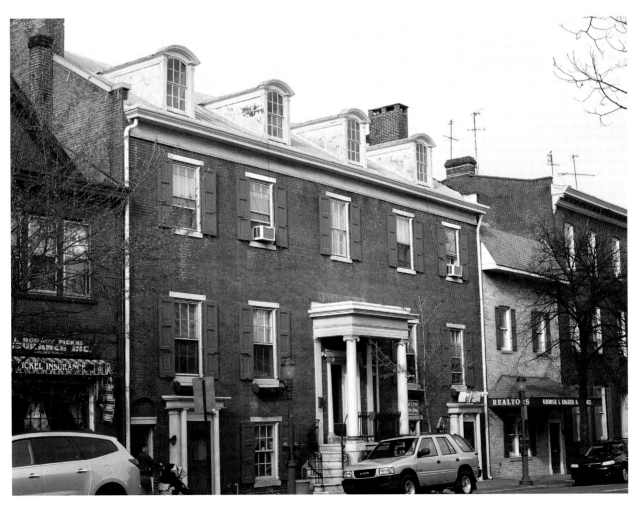

Bellaire House, c. 1830.

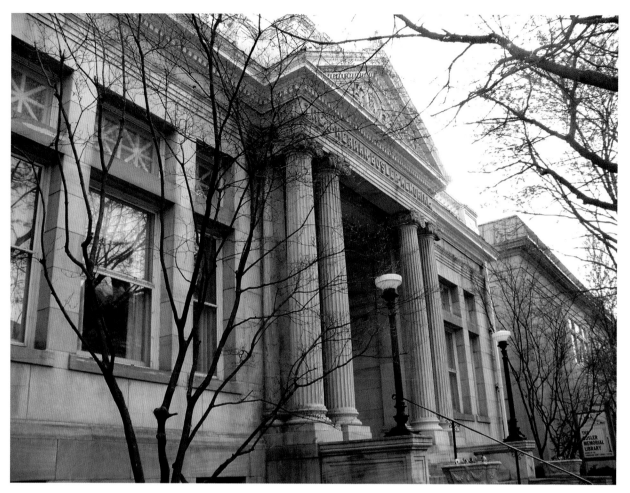

Bosler Memorial Library, c. 1899.

BOSLER MEMORIAL LIBRARY, 158 West High Street: Constructed during 1899, the Neoclassical style building with Ionic columns was a gift from the family of J. Herman Bosler. The library opened January 19, 1900. Two fireplaces in the original portion of the building have light green tiles bearing an olive wreath and torch. An addition was completed on May 2, 1987, and the Children's Library opened on April 13, 1994. In the fall of 2011, ground was broken for yet another addition. In 1794, two taverns occupied this corner.

Denny Hall, c. 1905.

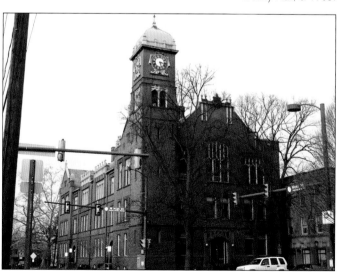

DENNY HALL, northeast corner of High and West Streets: Built in 1905 in the Late Victorian Gothic style, this is the spot where President Washington stood beneath a locust tree reviewing troops in 1794, on the way west to quell the Whiskey Rebellion. President Washington was the only U.S. President to take command in the field as Commander-in-Chief. It has been said that a section of that locust tree was carved for the ceremonial mace of Dickinson College.

REED HOUSE, southwest corner of West High and South West Streets: Built in 1833 by Judge John Reed, this is the current residence of the President of Dickinson College. The original limestone foundation of Judge Reed's smaller one-story brick house is still visible. Judge Reed's law program was the foundation for the Dickinson School of Law. At one time it housed the first law school in Pennsylvania and the fifth oldest in the country. The lawn portion of this corner is where the Allison Memorial United Methodist Church once stood until a fire destroyed it in the 1950s.

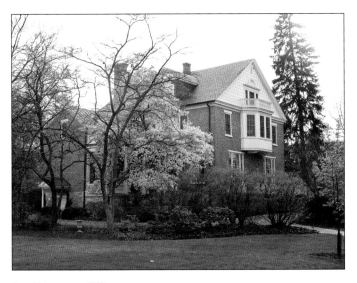

Reed House, c. 1833.

TRICKETT HALL, DICKINSON SCHOOL OF LAW, South College Street: Built in 1918, the law school was founded in 1834. It is the oldest law school in the state and the fifth oldest in the nation. One of its earliest graduates was Civil War Governor, Andrew Curtin. In 1997, Penn State University and Dickinson School of Law merged. The law school was remodeled from 2006-2010 with new advanced technology; it is currently the only one in the nation able to link students in other areas, such as British Columbia, Australia, and South Africa.

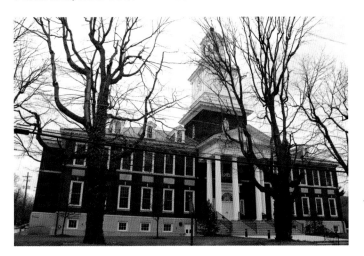

OLD WEST, DICKINSON COLLEGE, West High Street: Built between 1804-1822 and listed on the National Register of Historic Places, the building was designed for free in 1803 by Benjamin Henry Latrobe, the supervising architect of the U.S. Capitol. The three-story limestone is U-shaped with red sandstone window architraves and arches. A cupola sits in the center between two side gables. The original land area of the college is enclosed by a limestone wall. It is one of the most notable of all American college structures.

Although classes were first held in Old West in November 1805, roots of the college can be traced back to a grammar school near the square in 1773. The motivating person behind the founding of the college was Benjamin Rush, a Philadelphia physician and signer of the Declaration of Independence. The college took its name from John Dickinson, an original trustee, signer of the Declaration of Independence, and President of the Supreme Executive Council of Pennsylvania. The college closed from 1816-1821, and again for one year in 1832. The Law Department was established in 1833 with the first law degree granted in 1836. This later became the Dickinson School of Law in 1890, and has been independent of the college since 1917. Among Dickinson College's earliest graduates was U.S. President James Buchanan. Donors include President Thomas Jefferson and Benjamin Franklin. Confederates used the campus as a camp during its invasion of Carlisle in 1863, with the grounds serving as a hospital after the Battle of Gettysburg. The Washington Redskins football team held training camp at the college from 1963-1994 and again in 2001-2002.

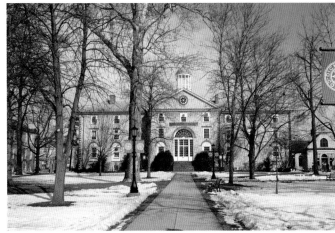

Old West, Dickinson College, c. 1803.

Trickett Hall, Dickinson School of Law, c. 1918.

CARLISLE HOUSE BED AND BREAKFAST, 148 S. Hanover Street: Built in 1826, this red-brick house is located within the Downtown Historic District. Accommodations include rooms and suites with private baths. At one time, this structure housed the Ewing Brothers Funeral Home.

POMFRET STREET offers many shopping and restaurant choices. Located on this block: The smallest house in Carlisle (58 West Pomfret) at just eight feet wide; a 1798 one-story log home (48 West Pomfret), with a second story that was added in the nineteenth century; and The Sign of Ship Tavern, which was run by Jacob Riser in 1794, at 41 West Pomfret Street.

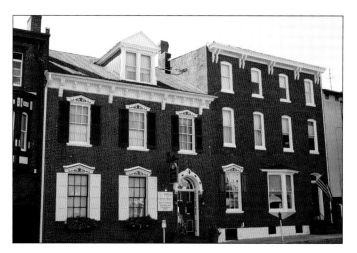

Carlisle House, c. 1826.

Quaint shops on Pomfret Street.

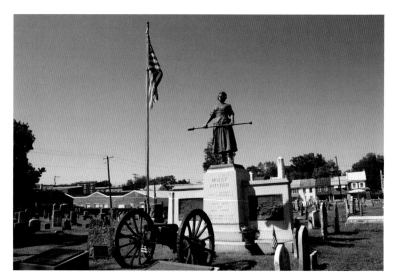

Molly Pitcher Statue in the Old Graveyard. The graveyard was in the original town plan of 1751.

THE OLD GRAVEYARD, East South Street: This is the statue and grave of Revolutionary War heroine and legend, Molly Pitcher. Thomas Penn stipulated that the location of the graveyard be on the outskirts of town in the original 1751 town plan. One of seven public graveyards in Pennsylvania, it is often referred to as the Westminster Abbey of Pennsylvania with the number of notable Americans resting here; they include: General John Armstrong (Kittanning Expedition and French and Indian War), Col. William Thompson (first commissioned officer in Continental Army), Mary Hays McCauley (Molly Pitcher), Dr. Charles Nisbet (first President of Dickinson College), Chief Justice John Bannister Gibson (Chief Justice of PA Supreme Court), James Hamilton (helped develop public education in PA), and Judge Frederick Watts (President of Cumberland Valley Railroad and instrumental in founding of Penn State University). The limestone wall was erected in 1806 to keep out wandering cows. The east wall was used by Union soldiers as a defense line during the Confederate Invasion of 1863, and one gravestone bears a hit. The last burial here was in the 1990s.

THORPE MONUMENT: The monument was dedicated in 1951 to honor the athletic achievements of Jim Thorpe, a 1912 Olympic winner of the decathlon and pentathlon in Stockholm, Sweden. He was a student at the Carlisle Indian Industrial School, where he played football. In 1950, he was voted the greatest athlete and football player of the first half of the twentieth century.

J.P. BIXLER HARDWARE STORE, 2 East High Street: Built circa 1856-1859, this three-story Italianate brick was also known as the Jacob Zug Store. The Bixler Hardware Store, one of the oldest hardware stores in the U.S., was founded in 1846; it was located here from 1907 until it closed in the 1980s and was converted to county offices.

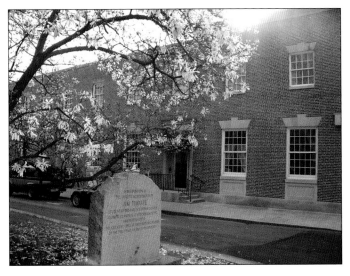

Thorpe Monument, dedicated in 1951.

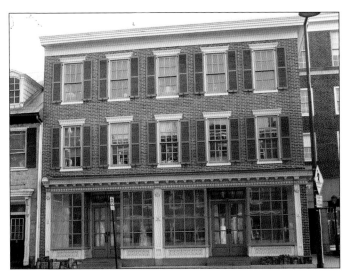

J.P. Bixler Hardware Store, c. 1856.

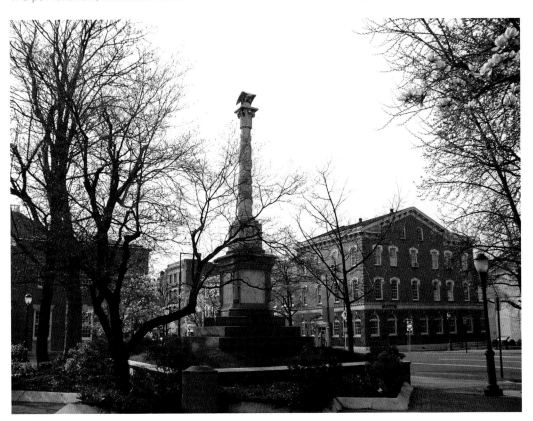

Soldier's Monument, c. 1876.

SOLDIERS' MONUMENT: Located beside the Old Cumberland County Courthouse, the monument was erected in 1876. It bears the names of seventeen officers and 325 enlisted men from Cumberland County who died in the Civil War.

UNION FIRE COMPANY, 35 West Louther Street: The tower side of the building was built in 1881 with an open Queen Anne bell tower. This fire company was founded in 1789, and is the oldest continuous volunteer fire company in the United States. Maintained in near original condition are the Meeting and Engine rooms. The fire company still provides fire protection to the citizens of Carlisle today.

47 MULBERRY AVENUE: Traditional Folk Log structure with exposed logs, it is listed in the National Register of Historic Places. All openings were altered in the nineteenth century. Inscribed is: "Built 1759, Repaired 1927." The first owner was John Reed.

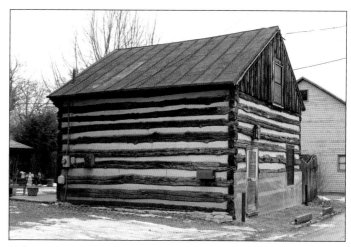
Mulberry Avenue Traditional Folk Log, c. 1759.

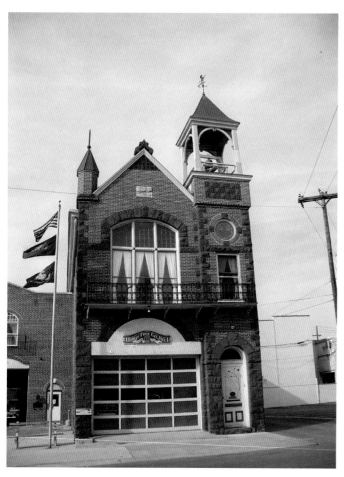
Union Fire Company, c. 1881.

EPHRAIM BLAINE HOUSE, 4 North Hanover Street: This circa 1794 Federal style brick, 2½-story home also has some Georgian elements. It was once half of a twin house that faced Presbyterian Church. It was built for a friend of George Washington. Ephraim Blaine was a Commissary General of the Continental Army, but never lived in the house because of his desire to marry a younger woman. He sold the once-twin homes to his sons. A tavern was operating in the stone portion at the rear of the building in 1775. It is currently the home to law offices.

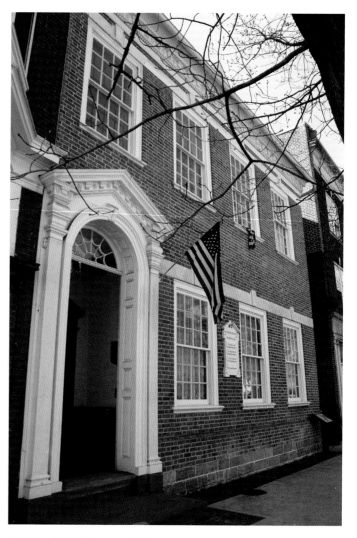
Ephraim Blaine House, c. 1794.

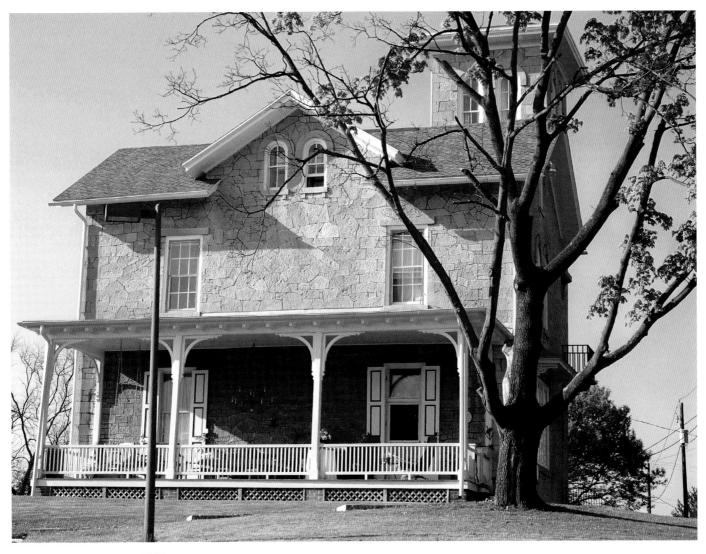

William J. Shearer House, c. 1867.

THE WILLIAM J. SHEARER HOUSE, 505 West Orange Street: Built circa 1867-1870 and located at the extreme western end of Carlisle, this Italian Villa stone residence was also known as the Greystone. The irregularly cut limestone is said to have been quarried on the lot. It is a true Italian villa with a rectangular massing peaked with a shallow gable roof and three-story tower with a small balcony on the first floor. Shearer acquired the land in 1862, and built the home for his wife, Mary A. Strock, and his seven children. The estate includes a stone carriage house in a simplified Italianate style, and now houses two apartments.

Stone carriage house on historic Shearer property.

Thornwald Mansion

Located at Thornwald Park on Walnut Bottom Road, on the southwest end of Carlisle, Thornwald Mansion is a Georgian Revival brick built in 1910 by Lewis Sadler, Esquire. The magnificent home was estimated to stand at least 1,000 years. Known for many years as "Noble's Woods," the tract of land was previously owned by Dr. Joseph W. Noble of Hong Kong, China, formerly of Carlisle, and included forty-six acres.

Designed by architects Hill & Stout and contractors, Thompson-Sterrett Co., all of New York, fine driveways and shrubbery made it one of the most beautiful and costly homes in this part of Pennsylvania. In August 1910, there were one hundred men working on the home. The house had forty rooms with a Rathskeller, an ice manufacturing plant, a hot water heating plant, vacuum cleaner with connections in each room, storage room, coal rooms, and large compressed air tank to force water to the third floor. The cost was estimated at $250,000. The Evangelical Reformed Church purchased it in 1952 for a home for the elderly. The Carlisle School District bought it in 1967 as a potential middle school site. The Borough of Carlisle bought it in 1976. The estate and two acres were sold privately with all the remaining land retained as a borough park.

Sadler graduated from Yale College, and the Dickinson School of Law in 1895. In June 1902, he married Miss Mary Bosler. The estate at one time contained an eight-car garage, private greenhouse, ten baths, five servants, burglar alarm, and a large lawn with a 9-hole golf course. Iron gates can be pulled across the first-floor windows. Legend has it that the mansion was named for thorny trees at the entrance of the property. The building was abandoned for approximately ten years prior to a fire that damaged it on August 21, 2007. The *English Gentleman* painting now at the Cumberland County Historical Society was a piece of art that hung at Thornwald Mansion. The damaged mansion still stands and was recently purchased with the intent of restoring it and turning it into a bed and breakfast.

Comprised of land that once belonged to Sadler and was part of his Thornwald Mansion estate, Thornwald Park, along Walnut Bottom Road, is the site of the county's largest and oldest trees and wildflowers.

Thornwald Mansion ruins, c. 1910.

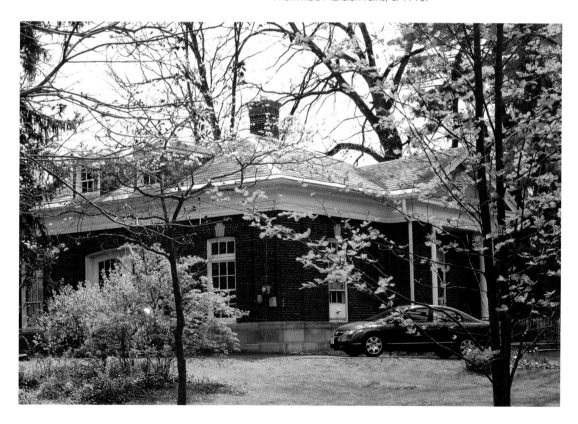

Gatehouse on Thornwald Mansion property.

White dogwood tree
at Thornwald Park.

Lawn at Thornwald Park with blooming spring trees.

Blooming spring flowers at Thornwald Park.

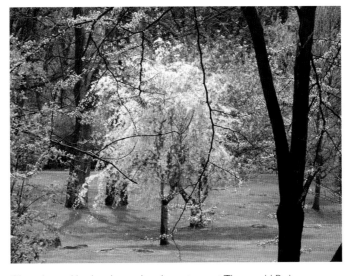

Blooming red bud and weeping cherry trees at Thornwald Park.

Carlisle Barracks
(formerly Washingtonburg)

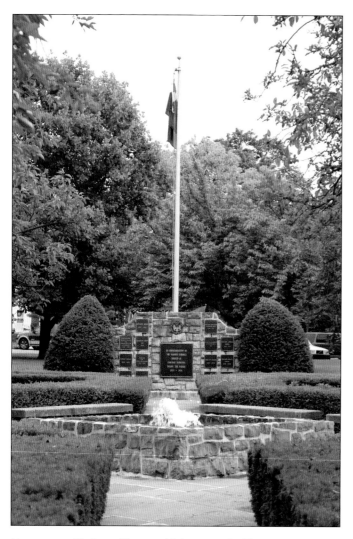

Monument with Army Bicentennial time capsule. The monument is in commemoration of various schools housed at Carlisle Barracks beginning in 1777. An Army Bicentennial time capsule at the base of the monument is to be opened in 2075 for the Army Tri-Centennial.

Carlisle Barracks – Army War College is the second oldest army post in the United States. It was formerly called Washingtonburg, the first site named after George Washington. It was burned by the Confederates on July 1, 1863, just before they marched to the Battle of Gettysburg. It served as an Indian School from 1879-1918 and an Army Medical Field Service School from 1920-1946.

It has been used almost continuously from the Seven-Year War when expeditions were launched here against the French troops at Fort Duquesne. The site of the Carlisle Barracks had been a British camp area since 1757.

The Gateposts were built during or before 1918. The four-brick gateposts define the former entrance to the Indian School campus. They support small limestone terra-cotta spheres. The two larger piers define the vehicular gateway while the two smaller ones define the pedestrian gates.

THE HESSIAN GUARD HOUSE, corner of Guardhouse Lane and Garrison Lane: Built in 1777 by Hessian prisoners captured at the Battle of Trenton as a stone powder magazine and later used as a prison, it is on the National Register of Historic Places. The solid stone walls are 4½ feet thick and lined with brick inside. There are three main rooms and four solitary cells. It was built when the British were threatening the eastern seacoast towns of the colonies; General George Washington removed ordinance works and supplied depots inland. Stored here were sulphur, brimstone, and other explosive ingredients.

The Carlisle Indian Industrial School used incarceration in the old guardhouse as a discipline for drunkenness. In 1918, the structure was used as a quartermaster, medical supply storehouse, and filmstrip laboratory when it was a station for General Hospital No. 31. It also served as a message center in 1940, a branch of the U.S. Post Office for the Barracks in 1942, and became a museum in 1948.

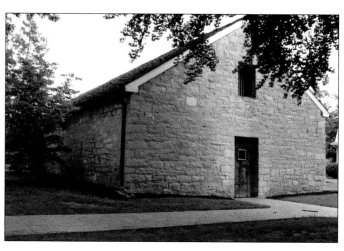

Hessian Guard House, c. 1777.

ANNE ELY HALL, Carlisle Indian Industrial School, is named for Anne S. Ely, 1834-1914. Ely was Superintendent of the Vocational Training Program for Indian students and was a member of the Carlisle Indian Industrial School faculty for twenty-eight years.

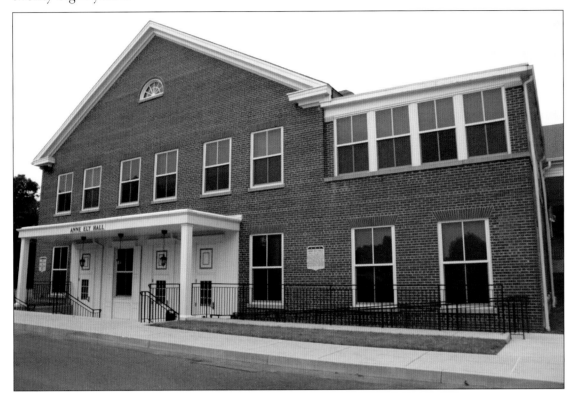

Anne Ely Hall, named after the Superintendent for Indian students.

CARLISLE INDIAN INDUSTRIAL SCHOOL, a National Historic Landmark, includes grandstands and a large playing field with cinder track. Indian Field was built by and for the Indian athletes of the school, and some of the athletes who gained athletic fame on this field were Jim Thorpe, Frank Mt. Pleasant, Louis Tewanima, Isaac Seneca, James Johnson, Frank Hudson, Charles (Chief) Bender, Lonestar Dietz, and Bemus Pierce.

WASHINGTON HALL, the two-story, clay-bonded structure with a stone foundation was built in 1884. It has a columned one-story porch and was named in honor of General George Washington, who participated in two expeditions launched from Carlisle Barracks. It was originally used as a hospital by the Indian School and later a dining hall; it also served as a dormitory for the famous teams of Pop Warner. In 1951, it was converted to a guest house.

Indian Field, built by the Indian athletes.

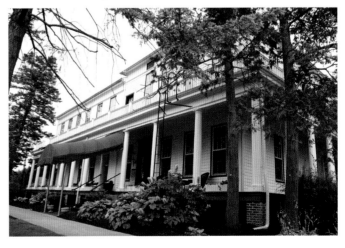

Washington Hall, c. 1884.

THORPE HALL is a gym that was built in 1887 by Indian students, enlarged in 1895, and renovated in 1976. The brick structure is 1-1/2 stories with random coursed fieldstone foundation and brick pilaster strips. Jim Thorpe was an Olympic athlete who won four of five Pentathlon events and six of ten Decathlon events in 1912. Thorpe was a Carlisle Indian School student from 1904-1909 and 1911-1913.

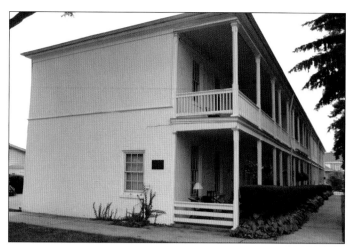

Coren Apartments (Indian School dorm for girls), c. 1863.

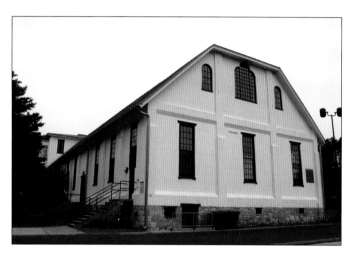

Thorpe Hall, c. 1887.

COREN APARTMENTS: Named for Captain Isaac Coren, organizer of the first artillery school of the American Army at Carlisle Barracks in 1777, the structure was initially used as a girls' dormitory for the Indian School. Since 1918, it has served as officers' quarters. The building burned in 1863. The long two-story brick structure with a double-story portico and chamfered posts was rebuilt on the original plan after the burning of the Barracks in 1863. The Gazebo (Wheelock Bandstand) was built in 1980 at the site of the original 1867 bandstand. It was named in honor of Dennis Wheelock, an 1890 graduate of the Indian School and the school's first Indian Bandmaster.

Gazebo, c. 1980.

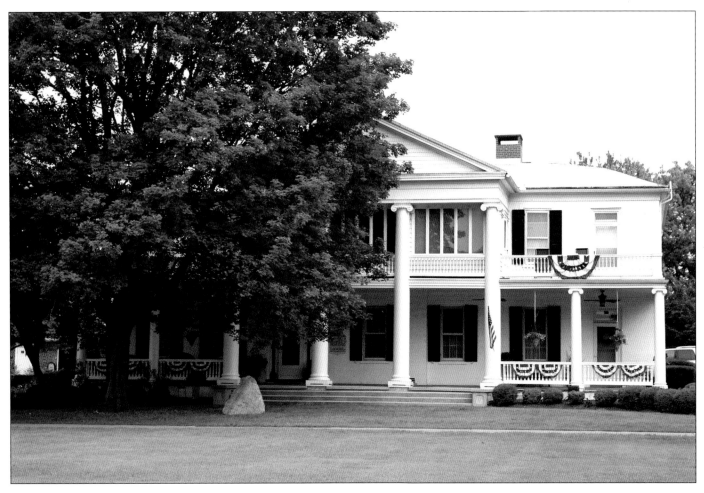

Quarters 2, quarters to commanders at Carlisle Barracks.

QUARTERS 2: First built in the 1700s, it was the site of headquarters for Colonel Stanwix of the British Army. It was burned during the Civil War by Confederates under Jeb Stuart. It has been the quarters to commanders at Carlisle Barracks from its earliest days to the present and was the home to the founder of the Indian School, Richard H. Pratt, from 1879 to 1918.

Old Farmhouse, c. 1853.

OLD FARMHOUSE, at the end of Sumner Road at 839A Patton Road, was built circa 1853-1856. This two-story white-brick home was used by Confederate soldiers during the Civil War. It was an educational farm to the Carlisle Indian Industrial School. During World War II, it was an on-post social club for African-American soldiers. It has served as housing for military families over the years. It is scheduled to be demolished in 2012 to make way for building housing for four families.

THE ARMY HERITAGE AND EDUCATION CENTER, 950 Soldiers Drive, Carlisle, offers a 56-acre campus, including the Military History Institute at Ridgway Hall; a public research library and archives for the personal papers of soldiers and their families; and the Army Heritage Trail, an outdoor museum that captures the life of soldiers. Two living history events are held here annually: the Army Heritage Days in the spring and fall events whose themes have included the Revolutionary War, the Civil War, and the War of 1812. It opened in 2002, with a second building opened in 2011.

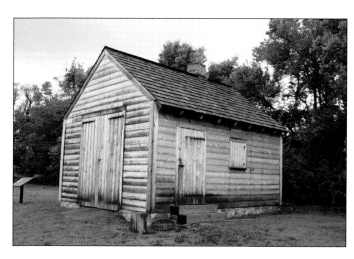

Log structure on Army Heritage Trail.

Army Heritage and Education Center, c. 2002.

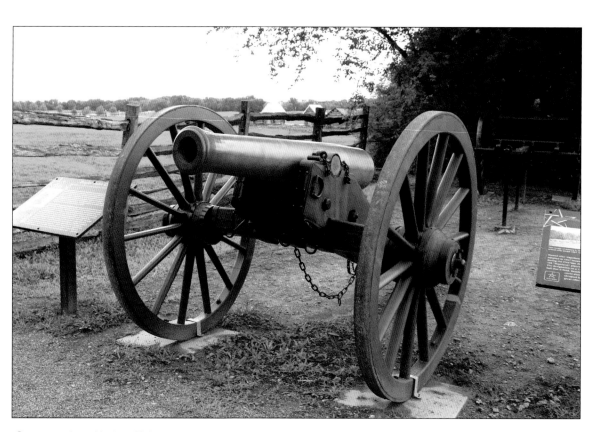

Cannon on Army Heritage Trail.

Country Areas of Carlisle

Outside the city limits of Carlisle, the countryside areas also have many beautiful architectural buildings and homes, most of which were originally on large tracts of land. Many farms still exist today throughout the Cumberland Valley between the North and South Mountains.

THE TWO MILE HOUSE, 1189 Walnut Bottom Road: Located two miles from the Carlisle Square, this Federal limestone was built in 1820 and sits on six acres. The property includes a wagon shed (now a garage), a chicken coop, and tool shed. The portico was added circa 1840, and a one-story addition in the 1920s. It has a rear kitchen ell with a large cooking fireplace. The bake oven door still remains. It is listed on the National Register of Historic Places.

The house served as the James Given Tavern from 1826-1857, offering travelers simple food and lodging. The house includes twelve rooms with ten fireplaces. The northwest parlor mantel was featured in the *Architectural Record* in July 1921. It was purchased in 1946 by J. McClain and Mary Wheeler King, who lived here until 1992. They bequeathed the house and property to the Cumberland County Historical Society. The McClain Celtic Festival is held here each Labor Day weekend.

HISTORIC JUDGE JOHN STUART HOUSE, 238 W. Old York Road: This Italianate brick farmhouse mansion was built for Judge John Stuart in the 1850s. Legend has it that horses were hidden in the basement of this home during the Civil War. The home has fourteen-foot-high ceilings, eight fireplaces, including beautiful walk-in brick fireplaces in the kitchen and summer kitchen, and a grand staircase elegantly curves to the third floor attic. In 2006, extensive renovations began on the home that now includes a twelve-car garage, which replaced a barn that burned when struck by lightning.

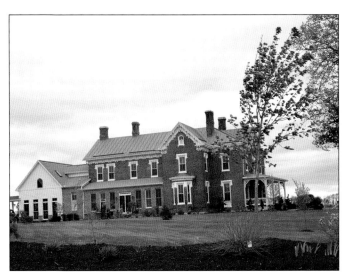

Judge John Stuart House, c. 1850.

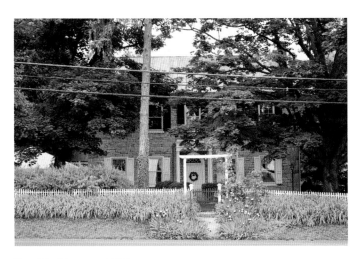

Two Mile House, c. 1820.

STONE TAVERN, located at Mooredale on Walnut Bottom Road, seven miles west of Carlisle: Also known as the Cumberland Hall Tavern and Moore's Tavern, it was built in 1788 by James Moore, who left Ireland in 1740. The Georgian/Traditional Folk stone is 2½ stories with a two-story kitchen ell. It operated as a tavern from 1798-1885 and was both a social and political gathering place. Country dances were held upstairs while business was conducted in the tap room. On occasion, hearings and trials were held here.

In 1811, a court case involved the tavern. A stone church was erected across the road in 1809, and church members realized it was too difficult to hold prayer meetings so close to the popular public house and tried to have the liquor license revoked. Appeals failed and church members moved the church away stone by stone. President George Washington passed the tavern on October 11, 1794, on his way to quell the Whiskey Rebellion. In 1812, James Moore, Esquire, was indicted for keeping an office of the justice of peace at the tavern. A spring runs through the basement. The property also includes a small brick tollhouse and a small stone and frame barn.

WAGGONER'S GAP HOUSE, 3421 Waggoner's Gap Road, Carlisle: The two-story stone home was built in 1817. Tavernkeepers included Jacob Waggoner in the 1790s and Abraham Waggoner from 1829-1847.

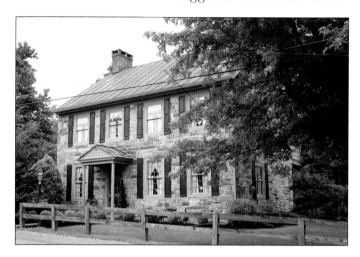

Waggoner's Gap House, c. 1817.

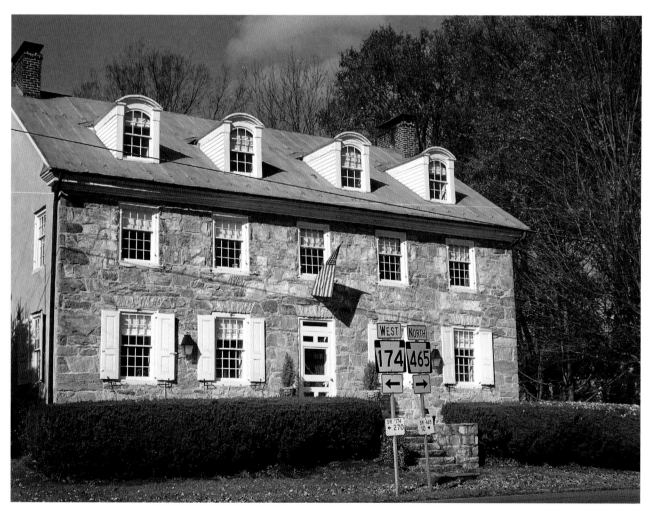

Stone Tavern, c. 1788.

DICKINSON PRESBYTERIAN CHURCH, 12 Church Road, situated eight miles southwest of Carlisle: Known as "the friendly church in the country," the structure was built in 1827, although the church was founded in 1823. In 1925, the church purchased a one-room schoolhouse situated across the road from the church. It was enlarged and renovated as the Parish House with much financial support from Miss Mary Cameron of the Cameron family who summered at Kings Gap.

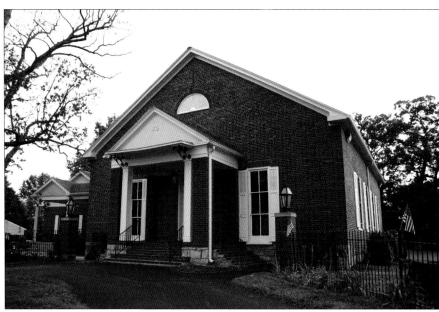

Dickinson Presbyterian Church, c. 1827.

Kings Gap Mansion, c. 1908.

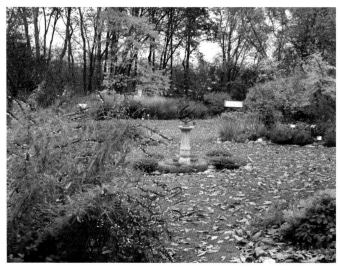

Sun dial in garden at Kings Gap.

KINGS GAP ENVIRONMENTAL EDUCATION CENTER, 500 Kings Gap Road: Sitting in the South Mountain, Kings Gap can be seen from the valley miles away. Beautiful panoramic views of the Cumberland Valley can be seen from the Cameron/Masland Mansion. James McCormick Cameron erected the 32-room mansion as a summer home around 1908 to resemble an Italian villa. It was built from native Antietam quartzite quarried from a nearby ridge.

After Mr. Cameron's death in 1949, C.H. Masland and Son Carpet Company of Carlisle purchased the mansion and 1,430 acres and called it the "Masland Guest House" for accommodations for potential clients. The Maslands owned it from 1951-1973 when the Commonwealth of Pennsylvania acquired it. The grounds are open to the public year-round. Buck Ridge Trail, a six-mile hiking route rated as most difficult, connects Kings Gap with Pine Grove Furnace State Park.

Scenic road leading to Kings Gap.

PINE GROVE FURNACE STATE PARK, Route 233, Cooke Township: The park has seven hundred acres, two lakes, and seventy-four campsites. It is located on the site of Pine Grove Furnace Iron Works dating back to 1764. Only the furnace stack remains; it was once surrounded by a large factory. Fuller Lake was previously a huge ore pit that supplied the raw ingredient used to make two to three tons of iron each day until the late 1880s.

Several historic buildings also remain: Iron Master's Mansion was built circa 1820 during the Ege family's ownership and is now a youth hostel frequented by hikers of the Appalachian Trail. Grist Mill had renovations in 2010 to transform its 200-year-old stone and beam building into an Appalachian Trail Museum. The mill is located two miles from the midpoint of the entire Appalachian Trail, which extends from Mount Katahdin, Maine, to Springer Mountain, Georgia, and is listed on the National Register of Historic Places.

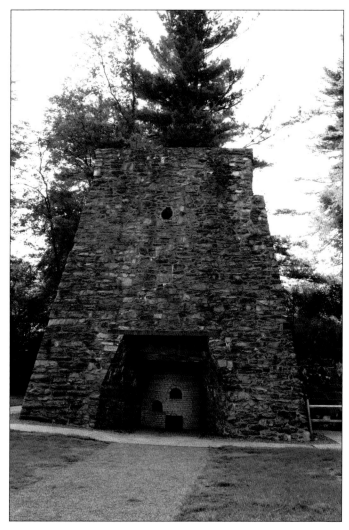

Pine Grove Furnace Stack.

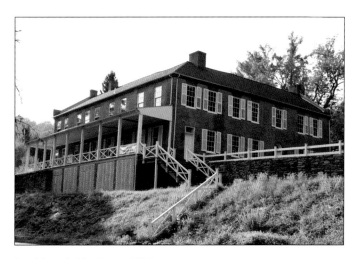

Iron Master's Mansion, c. 1820.

Stream at Pine Grove Furnace.

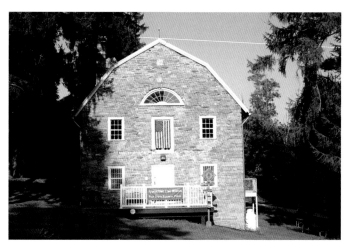

Grist Mill, c. 1810.

More historic buildings that remain at the park include the Pine Grove Furnace Store, where hikers on the Appalachian Trail traditionally obtain and eat a half-gallon of ice cream to celebrate the half-way point of hiking the trail. This building was originally the mule stables. At the Paymaster's Office, c. 1910, imagine the workers on payday going up one set of outside stairs to receive their wages and then back down the opposite side. Pine Grove was purchased by the state in 1913. Many visitors would carve their names at this location — and my father, Ronald Lebo, who was in the Class of 1956 at Carlisle High School, did just that. For a great view, climb three-quarters of a mile up to Pole's Steeple from the back side of Laurel Lake on Old Railroad Road.

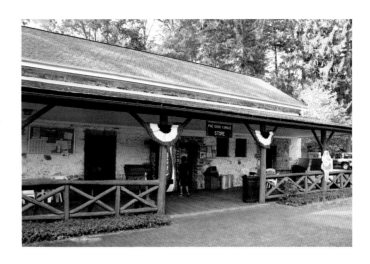

Pine Grove Furnace Store, originally mule stables.

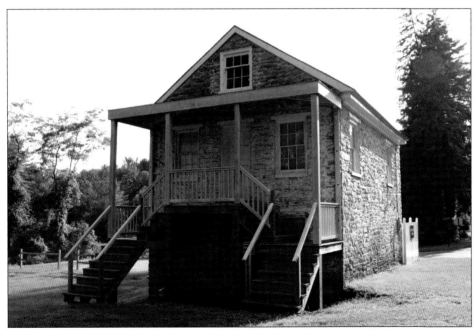

Paymaster's Office, c. 1910.

Pole to Pine Grove Furnace Store.

The Road of Taverns

In the early nineteenth century, Walnut Bottom Road was a bustling thoroughfare for drovers taking livestock to eastern markets. Conestoga wagons, stagecoaches, and freighters traveled with up to five hundred pack horses. This road became known as "The Road of Taverns."

"**Weakley's Tavern**," 2675 Walnut Bottom Road, Carlisle: Circa 1790, the two-story Federal style brick was also known as "PA Coat of Arms" and "Brick Tavern." Located nine miles west of Carlisle, it is the earliest extant brick tavern house in western Cumberland County. It retains original windows and brick work. In 1798, the property had a two-story brick house, one-story brick kitchen, stone mill house, and stone smoke house. Tavernkeepers included Samuel Weakley (pre-1805), John Isett (in 1805), Robert Walker (1806-1809), John Weakley (1810-1826), and James Weakley (1826-1833). Community dances were held on the second floor.

"**Plough & Sheaf of Wheat**," 1879 Walnut Bottom Road, Centerville: The two-story stucco home includes three rooms on each floor. The cellar contains a cooking fireplace. Benjamin Smith was the tavernkeeper from 1803-1833.

Weakley's Tavern, c. 1790.

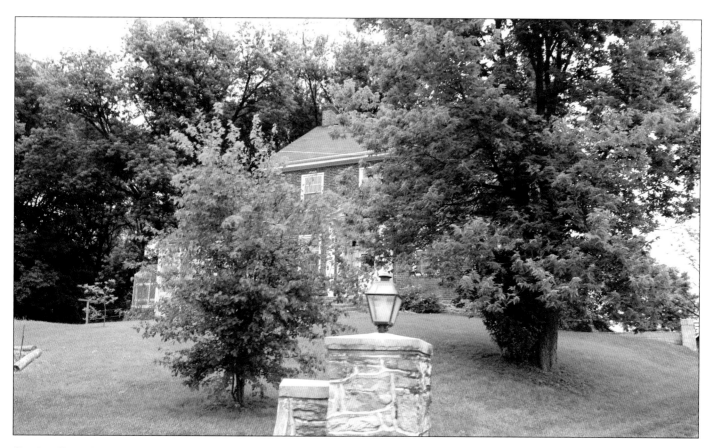

Plough & Sheaf of Wheat, c. 1803.

"**BRICK TAVERN IN SPORTING HOLLOW,**" 1805 Walnut Bottom Road, Centerville: The two-story brick was built circa 1808. Tavernkeepers included Samuel Beetem, Esquire (1818-1820), William W. Hite (1823-1826), Andrew Heagy (1830), Hugh Wallace-Counsellor at Law (1831-1834), Andrew Bushman (1835-1837), and Andrew Miller (1838-1839).

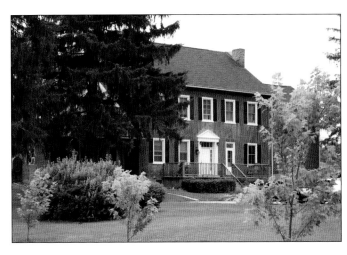

Brick Tavern in Sporting Hollow, c. 1808.

"**BRICK TAVERN AT SILVER HILL,**" 1777 Walnut Bottom Road, Centerville: The two-story brick was built 1820-1824, and is situated immediately west of Centerville on a hill. It has three front entrances with eleven-foot ceilings on the first floor and four rooms. There are four rooms on the second floor, including a ballroom. There are different fireplace mantels in each room. Wagon-making and blacksmith shops that existed in 1825 are now gone and were replaced with a stone-end barn with three cupolas. Tavernkeepers included Michael Wise (1824-1825), Samuel Lamb (1826-1829), and John Gregory (1829-1832). It was abandoned as a tavern in 1832 and converted to a store and dwelling by William Gillelland.

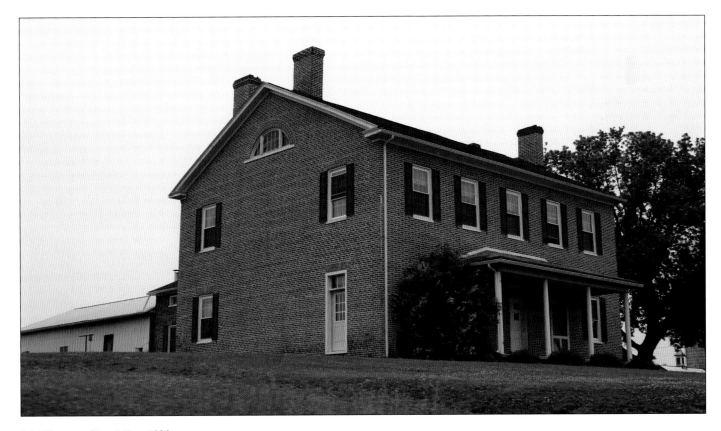

Brick Tavern at Silver Hill, c. 1820.

Section Two:
Cumberland Valley

The moon above trees and a local corn field display the rural beauty of this area.

Newville

Newville was incorporated on February 26, 1817. Around 1900, wooden fences lined the country roads as far as the eye could see, and the first trolley run was in November 1910.

In the rural Newville area, even during the 1940s, men would shovel the roads by hand. Most homes at that time had outhouses rather than modern bathrooms. One-room schoolhouses were common until Big Spring High School was built in the mid-1950s; Big Spring School District has its administrative offices in Newville. Despite having a low population, Big Spring School District is the largest in the county in terms of square miles covered.

Other interesting facts about Newville are:

• It was home to William Paris Chambers, the world's greatest cornetist of his day. He was the leader of the Keystone Cornet Band of Newville at age 18; became a cornet soloist of the 71st Regiment Band of New York City; and made four concert tours in Europe. He also played at the World's Exposition in Chicago in 1893, the Pan American Exposition in Buffalo in 1900, and in the Crystal Pallace, London, for the Crown Princess wedding in Berlin. He returned to Newville in 1912 in poor health and is buried in Prospect Hill Cemetery on Route 641 near Newville.

• From 1844 to 1882, Dr. John Ahl practiced medicine here. After being elected to Congress in 1856, he was one of the victims of a plot to poison President Buchanan, his cabinet, and advisors when he became very ill at a public dinner where several others died.

• During the Civil War, seventeen veterans from the War of 1812, aged 68 through 76, marched to the Capitol to confer with Governor Curtin and ask for duty in the trenches. The group carried a flag that their fathers had borne at the Battle of Trenton in 1777. This Newville unit was sent under Captain Sharp.

Daniel and Peter Ahl delivered a thousand horse and mules each to the Union Army during the Civil War. Daniel was made a honorary Colonel after delivering a large number of horses to General Avenill's command on the battlefield at Culpepper Court House, Virginia.

On June 27, 1863, the Rebels came to Newville looking for horses, food, and any valuables. Many animals had been taken away while valuables were hidden under floorboards, in old rags thrown in corners of yards, or buried, and the Rebels found little here.

• The State Police School was at one time located here. It was established in 1920 at the former Cumberland Valley Railroad Station, also known as the Big Spring Hotel, on Walnut Street near Big Spring Avenue. This Pennsylvania State Police Training School was the first of its kind in the nation. It was transferred to Hershey in 1923.

• "The Babes in the Woods" were found dead on top of the south side of Route 233, causing a nationwide search for the identities of the three young girls. A funeral was held for them in November 1934 at Westminster Cemetery.

• The John Graham Public Library, 9 Parsonage Street, was opened in 1960. When he died in 1915, Graham's will directed that his house be used as a library. His estate was not settled until the death of his third wife in 1963.

• The Newville Historical Society, 69 S. High Street, was formed in 1965. It is located in the Dougherty-

Historically known as Literary Hall, this 1854-1855 Greek Revival brick was originally used as a hall. The Big Spring Literary Institute built Literary Hall to promote learning among Newville area residents. In the late nineteenth century, the Lutheran Church held services on the second floor, and stores were located on the first floor. The third floor featured a stage on the north end and a gallery on the south end. The Cumberland Valley Normal School was opened here until the Civil War forced it to close. The Normal School relocated to Shippensburg State College, and a classical school was opened here. It is currently home to a bank, and plans are underway to restore the building.

Welch House that was bequeathed to the society from the Estate of Margaret Tritt Sollenberger.

• Randall Shughart was awarded the Medal of Honor in 1993. In 2005, the Newville Post Office was named after the Newville native. Shughart lost his life in courageous actions in combat during the Battle of Mogadishu, Somalia. In 2001, his story was depicted in the film, *Black Hawk Down*.

• The Big Spring Creek in Newville was at one time frequented for fishing by many famous people throughout the United States, and it is still popular for fishing locally.

• The former abandoned train tracks between Newville and Shippensburg are now public trails on Rails to Trails that extend eleven miles.

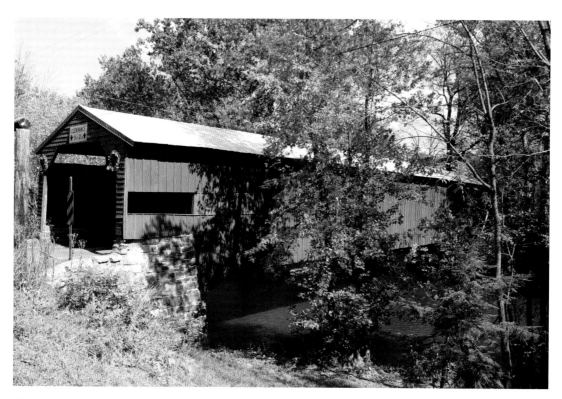

Covered bridge in western Cumberland County, off of Route 641, on Covered Bridge Road.

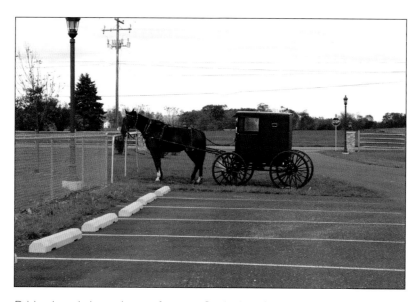

Driving through the rural areas of western Cumberland County, keep your eyes open for the beautiful horse and buggy. There are many Mennonite and Amish farms in the area that utilize a horse and buggy for traveling the roads. Gray buggies belong to the Amish while black buggies belong to the Mennonites.

Newville Landmarks

THE LAUGHLIN MILL, Route 641 at the east end of Newville: The oldest remaining building in the Newville area, the mill was built in 1760-1763 by William Laughlin. The first level is limestone while the upper two floors are oak and chestnut logs with full dovetail notching. The Laughlins operated the mill for three generations until it was sold in 1896 to the Newville Water Company. The first four lots to the west of the mill are where the first school building was built in 1796.

BIG SPRING ACADEMY, Route 641: Also known as Linwood, the academy was built and established in 1852 by the Rev. Robert McCachran as a classical school for boys and was later used as a girls' school. Today it is a private home located just east of the mill. On June 27, 1863, the Rebels camped on the grounds of this home.

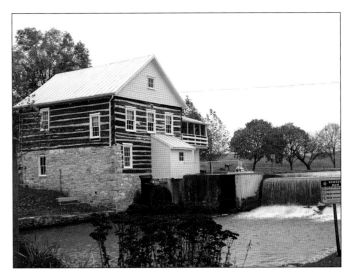

Laughlin Mill, c. 1760.

Linwood, c. 1852.

43

BIG SPRING PRESBYTERIAN CHURCH, S. Corporation Street: The Georgian style limestone was built in 1790 with a plan furnished by Rev. Robert Davidson, then pastor of the Presbyterian Church in Carlisle and afterwards President of Dickinson College. The church was heated by three stoves. A stone building stood at the north side of the church, known as the session house, and was used as a school for many years. The structure was remodeled twice in the nineteenth century when rectangular windows were replaced with gothic ones, a cupola added, and brick additions built. The first church erected in 1737 was a log structure that stood in the present graveyard, which lies on the south side of the church and contains the oldest marked stones in the Newville area. In 1790, the church laid out the town of Newville and sold lots for dwellings and pasture lots. William Denning's monument with marble cannon was dedicated in 1890. Denning was in the Revolutionary Army in New Jersey and the Pennsylvania Army under George Washington. He was instrumental in the making of cannons. He died at the age of ninety-four in 1830.

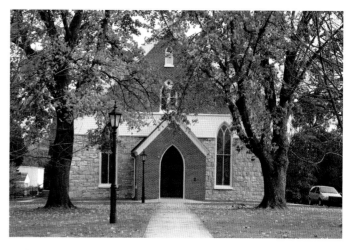

Big Spring Presbyterian Church, c. 1790.

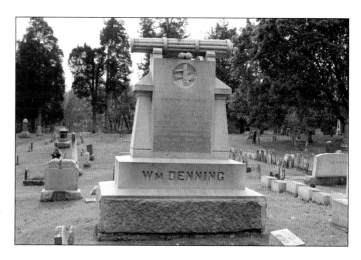

William Denning Monument, dedicated in 1890.

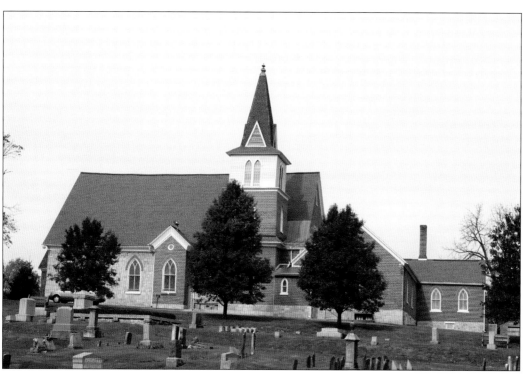

Big Spring Presbyterian Church. View from historic graveyard.

NEWVILLE FRIENDSHIP HOSE FIRE CO., East Big Spring Avenue: Built in 1858, this Popular Vernacular/Gothic brick was originally used as a school for all Newville students and contained six rooms. It was remodeled in 1915 with extra classrooms, an auditorium, gymnasium, electricity, and plumbing. From 1925-1956, it served as the Newville High School. It was rehabilitated in the 1960s to serve as a fire hall.

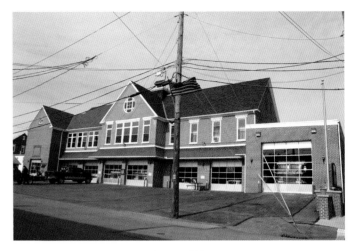

Newville Friendship Hose Fire Co., c. 1858.

ST. PAUL'S LUTHERAN CHURCH, Big Spring Avenue: This Romanesque/Gothic brick church was built in 1901. It is three stories with a large Gothic stained glass window on the second floor. The congregation previously worshipped in Literary Hall next door. Land for this church was donated by Dr. and Mrs. Ahl.

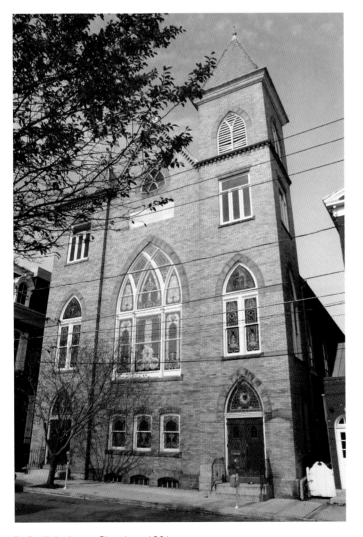

THE FOUNTAIN, located at the corner of Parsonage Street and West Street: Built in 1896, the Renaissance Revival stone base and pool fountain were erected by the citizens as a monument to the arrival of running water in Newville. It originally had cast iron Grecian urns that were replaced in 1931 with concrete ones. A fountain festival takes place annually in June.

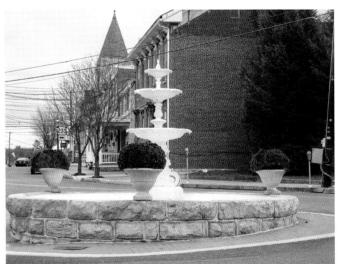

The Fountain, c. 1896.

St. Paul's Lutheran Church, c. 1901.

First United Presbyterian Church, 111 W. Big Spring Avenue: The church was founded in 1764, with the first meeting place in a tent along the Big Spring. In this same spot, a log church was built in 1772, a stone church in 1790, a brick church in 1826, and a two-story brick in 1868. The church burned on November 6, 1881, in a fire caused by janitors. The current church was built one year later. The architect was M. L. Valk of New York. This building was dedicated in February 1883. The bell in the belfry was dedicated by Newville citizens. In the twentieth century, an extension was added to the north side.

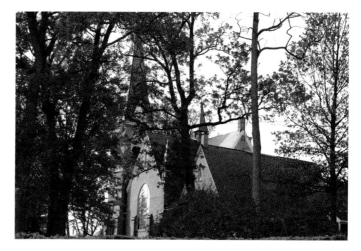

First United Presbyterian Church, c. 1882.

The Parsonage, 111 W. Big Spring Avenue: This building was erected in 1859 as the parsonage for the First United Presbyterian Church. Along the front of the property is the late circa 1900 fence. The front portico was added in the mid-twentieth century. This home was first occupied by the Rev. W. L. Wallace, who is remembered for his prayers for the success of the Union Army. The first bathroom in Newville was installed here.

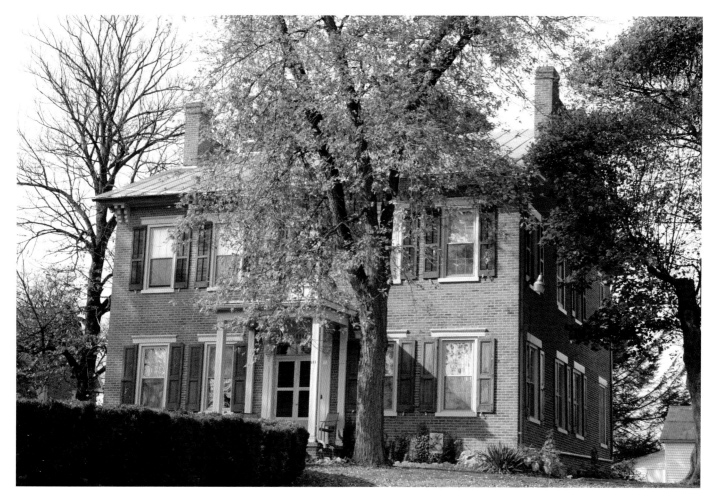

Parsonage to First United Presbyterian Church, c. 1859.

HERRON COTTAGE, 1 Parsonage Street: This Victorian Gothic brick was historically known as the Alexander Sharp house. It was built in 1858 by Johnson Herron and has a late nineteenth century iron gate and fence around the property. Ulysses S. Grant visited here 1870-1878 when it was owned by his brother-in-law, Major Alexander Sharp, MD. Local history claims that General Grant spoke from the second-floor balcony after the Civil War, but before he was president. The property burned in 1888 and was rebuilt in 1889 by G. W. Swigert.

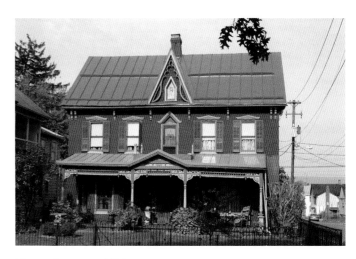

Herron Cottage, c. 1858.

THE BYERS-ECKELS HOUSE, Big Spring Avenue, circa 1860: The property was purchased by Anthony Byers in 1851 and evolved into this Italianate Victorian home during his ownership. Until 1985, a dumb waiter went from the lower-level kitchen to the dining room. In June 1863, when the Confederates occupied Newville, they stole lead weights from the family's tall case clock to be used for ammunition, but missed other family heirlooms that were buried in the rose garden.

ZION LUTHERAN CHURCH, 51 West Main Street: This Victorian Gothic brick church was built in 1862 during the Civil War. It has decorative brick work, attenuated round arch windows, and buttresses. The cornerstone was laid by the congregation in 1862. The original steeple was unsound and was replaced with the current steeple in 1894.

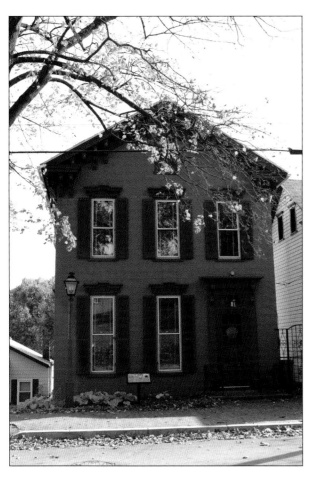

Byers-Eckels House, c. 1860.

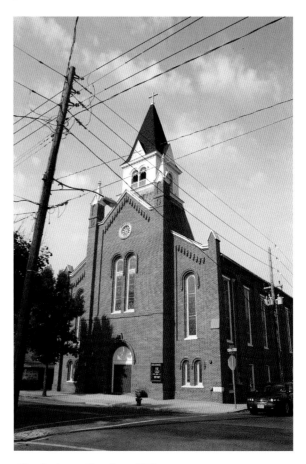

Zion Lutheran Church, c. 1862.

LOGAN HOUSE, 51-53 E. Main Street: Circa 1801, this two-story Federal stone was originally a tavern built by James Woodburn. He called his tavern "At the Sign of the Indian Chief." It was also known as Logan House and Central Hotel Tavern. In the twentieth century, a portico was added and a back two-story addition was built in the early nineteenth century. An ad describing the sale of the property on March 20, 1869, included ten rooms, bar-room, front and back parlors, kitchen, cistern at kitchen door, ice house, wood house, chicken coop, smoke house, pump at kitchen door, stone barn for forty horses, and garden 63 x 180 feet for growing large amounts of vegetables. James Woodburn died in 1823. Tavernkeepers were James Woodburn (1798) and (1803-1823), George W. Woodburn (1824-1836), J. C. Woodburn (1837-1838), and William Woodburn (1839).

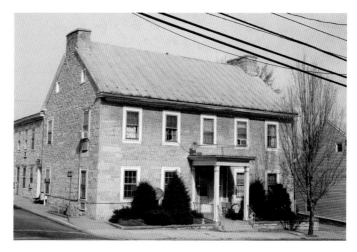

Logan House, c. 1801.

JACOB MYERS HOUSE, Mt. Rock Road across from the new high school: Circa 1790, this Georgian stone farmhouse has a full arch above all first-story windows, one second-story window, and the centered front door, which was mostly associated with Lancaster County Germans. The Myers family moved here from Lancaster. It also has a stone barn. While this farm was owned by Myers, Joseph Ritner worked here as a field hand. Joseph Ritner served as the Governor of Pennsylvania (1835-1839) and, as governor, put into practical operation the law of 1834 that established the public school system. Ritner is buried in the cemetery of Mount Rock United Methodist Church located at the intersection of Mount Rock Road and Route 11.

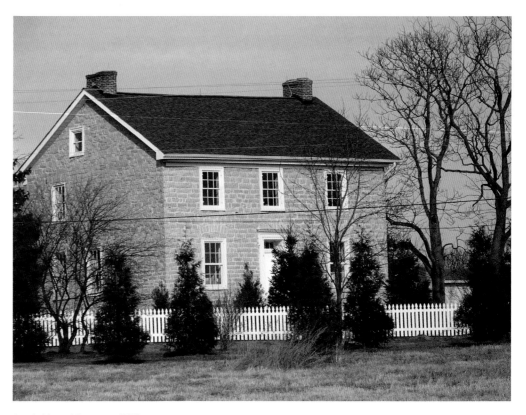

Jacob Myers House, c. 1790.

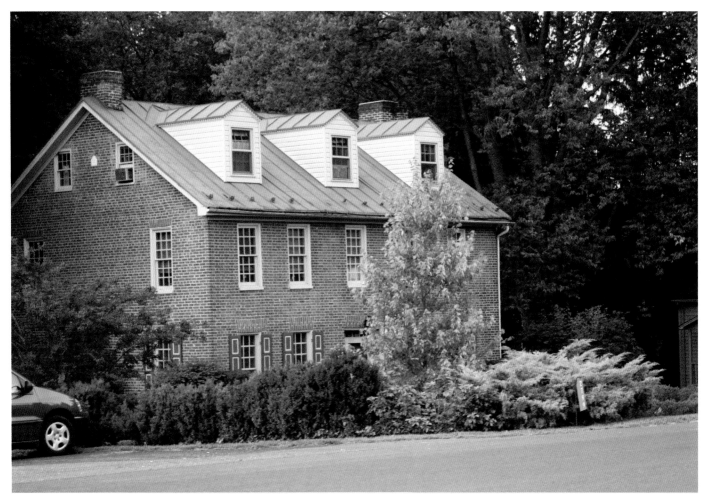

Mount Rock Tavern, c. 1833.

MOUNT ROCK TAVERN, 2799 Ritner Highway (west of Carlisle on Route 11, close to Mt. Rock Road): The two-story brick tavern was built before 1833 and replaced an earlier stone tavern. On October 11, 1774, troops camped at this tavern on their way west to put down the Whiskey Rebellion. In the early years, one could expect to travel fifteen to twenty miles per day by foot, horseback, wagon, or stagecoach. Unpaved dirt roads were filled with rocks, roots, and mud if it rained. Often, a 21-mile trip from Shippensburg to Carlisle was split by spending the night at Mt. Rock Tavern. Taverns housed men and their animals. This tavern was known as the tavern everyone stopped at for a rest.

John Miller bought the 500-tract in 1766. In 1798, the property included a stone dwelling house, log house, log kitchen, still house, and spring house. By 1833, the stone house was gone and replaced with the present brick house. The tavern was also known as "Sign of Spread Eagle" and "Sign of the Horse." Tavernkeepers were Widow Tenant (1753), Miller (pre-1759+), Robert Darlington (1770s), Robert Semple, son-in-law of Rev. John Steel of Carlisle (1782-1793), John Miller (1794-1800), John Wilt (1801-1806), Daniel Goebel (1808-1811), John Woodburn (1812-1817), Jacob Bigler (1820), John Miller (1820-1825), Martin Bibhauer (1826); Jacob Beltzhoover (1829), and John Trego (1833).

The beautiful home has been owned by the Shriner family since 1964.

DOUBLING GAP HOTEL, Route 233 north of Newville near Colonel Denning State Park: This was a famous resort in the nineteenth century, being well-known for its hotel and springs. It was built in 1850 by Scott Coyle because of the curative and healing quality of the mineral water. Some famous visitors here include the families of John Wanamaker, the DuPonts, Lewis the Robber, General Sutter, and General U. S. Grant. The ballroom was the scene of many lively parties and dances. Guests came to Newville by train and were met by an elegant coach named "The Tally-Ho," drawn by four black horses with a uniformed driver. The hotel accommodated 200-250 guests, having as many as 1,000 per season. The rocking chairs on the front piazza were usually filled. Guests spent time walking the tree-lined paths, swinging, using lawn ten-pin alleys, black-berrying, swimming, boating, and horseback riding. Mornings were spent reading or playing quiet games at the various spring summer houses. A portico the entire length of the building

afforded a delightful promenade. There were pleasant winding walks from the hotel to the springs and bath. In July 1855, a fireworks celebration was held here. The twin fountains are still fed by natural water pressure, which run twelve months of the year. Today it is used for summer camps and retreats, and is owned by the Church of God.

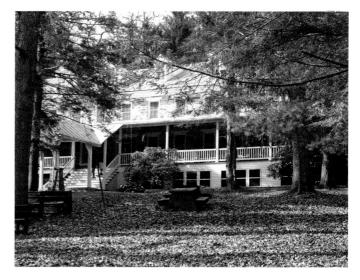

Doubling Gap Hotel, c. 1850, front view.

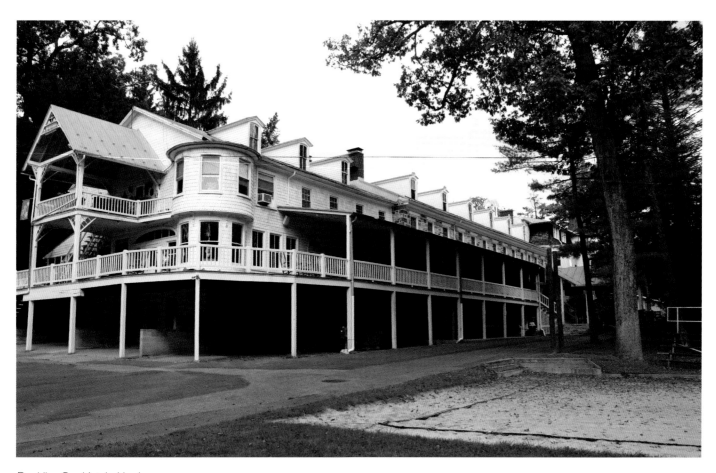

Doubling Gap Hotel, side view.

COLONEL DENNING STATE PARK, Route 233 north of Newville: The park has 273 acres, including eighteen miles of hiking trails, camping, and a 3½-acre lake with a beach for swimming and trout fishing. There are two playgrounds, volleyball courts, charcoal grills, and picnic tables. Colonel Denning sits in Doubling Gap, named for the "S" turn where the Blue Mountain doubles back on itself.

The park is named after William Denning, an American Revolutionary who manufactured wrought iron canons and was stationed just outside Carlisle at Washingtonburg Forge. After the Revolution, Denning lived near Newville and is buried in the Big Spring Presbyterian Church Cemetery. Around 1930, the park became a state recreational area and was developed formally in 1936. There are four primary hiking trails in the park ranging from easy to moderately difficult.

Stream at Colonel Denning State Park.

Lake at Colonel Denning State Park.

Gazebo near dam at Colonel Denning State Park.

VILLAGE OF SPRINGFIELD, Springfield Road just off of Route 11 South, between Newville and Shippensburg: Springfield is along the headwaters of the Big Spring Creek and was a bustling village in the 1700s, providing shoemaker, miller, and blacksmith services. In 1877, Queen Victoria of England ordered barrels of flour from the Manning Brothers of Springfield and for years thereafter. Pictured are a few homes from this quaint village. The log cabin can be rented for overnight stays.

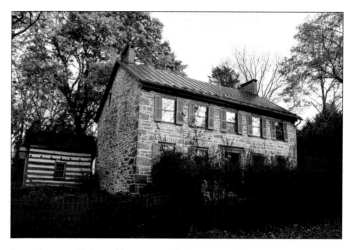
Stone home with log cabin summer kitchen, c. 1789.

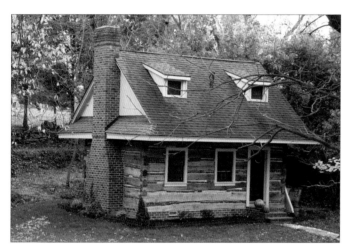
Log cabin in Springfield.

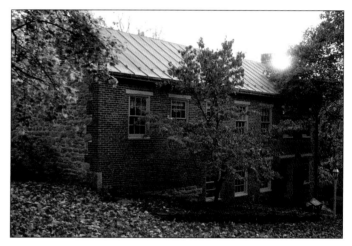
Brick and stone home in Springfield.

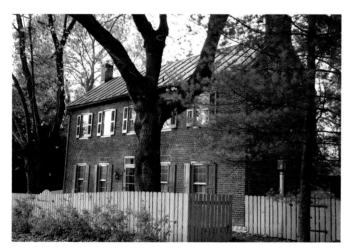
Brick home in Springfield.

Beautiful Flowers
and Scenic Views

Clockwise from the top left are the Knock-Out-Rose, Varigated Wiegelia, Crape Myrtle, and Russian Sage plants at my home. I inherited my mother's love for gardening. These are just a few of my favorites.

There are beautiful views in the Cumberland Valley during all four seasons. These photos are winter landscapes of a "bench with snow" and "berries in ice" taken at my home. My "berries in ice" photograph won third place at the 2012 Eastern Sports and Outdoor Show.

Shippensburg

March to Destiny events are held annually the last full weekend in June to remember the Confederate forces in the town of Shippensburg in June of 1863. Events include a Civil War Ball, encampment, street skirmishes, and a tea party in the downtown historic district. On June 23, 1863, Confederates were at full gallop with dust flying along Main Street. Left: Lincoln re-enactor at March to Destiny; Right: Re-enactors at March to Destiny.

In July 1730, the western outpost of colonial settlement began with Scotts-Irish families building cabins along Burd's Run. Shippensburg was founded in 1737, and is the oldest community in Cumberland County. It was founded by Edward Shippen, once the mayor of Philadelphia, who obtained from the heirs of William Penn the patent to the land. The Borough of Shippensburg is located in both Cumberland and Franklin counties. Court was held for a very brief time at the corner of King and Queen streets until the courthouse was moved to Carlisle in 1751. It is home to Pague and Fegan, the oldest continuously operating hardware store in Pennsylvania.

God's Acre burial ground, North Prince Street, has the first death recorded in 1733. It also contains soldiers' graves from various wars. During the Braddock Expedition in 1755, army supplies were stored in Edward Shippen's stone house at Route 11 and West King Street.

Shippensburg was touched by the Civil War during the summer of 1863 when invading Confederates camped there. These behind-the-scenes acts did not make all of the headlines that Gettysburg made, but played an important role in the days just before the Battle of Gettysburg. The Confederates were trying to acquire supplies and were attempting to bring the war to the north to remove the scene of the conflict from Virginia, where most of the war was fought for two years. The Confederates crossed the Mason-Dixon line on June 23, 1863, and a fourteen-mile-long wagon train of 20,000 soldiers reached Shippensburg on the 24th under Union Brigadier General Joseph Farmer Knipe. Many had gone out to Carlisle and Camp Hill in an attempt to invade Harrisburg by June 27th. Orders were changed to go to Gettysburg after skirmishes in

Camp Hill and Carlisle. The troops briefly rested in Stoughstown on the 29th, and a division passed through Shippensburg on their way to Gettysburg on June 30th.

The Locust Grove Cemetery/North Queen Street Cemetery includes the graves of twenty-six members of the United States Colored Troops. It is also where John and James Shirk of Mainsville are buried side-by-side in the southeast corner of the cemetery. The Shirk brothers served in the Union Army during the Civil War in the Massachusetts Regiment, which was the subject of the story *Civil War Times* and movie *Glory*. Another Shirk brother, Casper, was killed in the Battle of Fort Wagner and is buried on the beach of Morris Island.

Samuel D. Sturgis, a Union army general, was born in Shippensburg on June 11, 1822. His unit captured the Burnside Bridge during the Battle of Antietam. He watched a parade from the Georgian House on West King Street. Sturgis, South Dakota, is named after him.

Other interesting facts about Shippensburg are:

• Dicken's Day is held in mid-November for a trip back in time to the Victorian era.

• Local native, John Hamilton, starred as Perry White on the television series *Adventures of Superman* in the 1950s.

• Steve Spence, a local athlete, was a 1992 Olympian in Barcelona, Spain, and a Bronze Medalist in the 1991 IAAF World Championship marathon. He graduated from Lower Dauphin High School, and won numerous NCAA division two national titles in the 5000m run while attending Shippensburg University. He is the current Cross Country Coach and assistant Track & Field Coach at Shippensburg University.

Steve Spence's daughter, Neely Spence, was a recent stand-out athlete at Shippensburg University. She is an eleven-time NCAA All-American and the only athlete named the PSAC Athlete of the Year four times. She won eight NCAA Division II national championships, six in track and field and two in cross-country.

• The annual Shippensburg Fair is held the last full week of July, offering food, rides, music, pageant, crafts, and livestock displays.

• The Corn Festival is held within five blocks of the downtown area streets with artisans and vendors. It is held annually on the last Saturday of August with an estimated 60,000-70,000 people in attendance.

• H. Ric Luhrs Performing Art Center is a 1,500-seat state-of-the-art center at Shippensburg University.

• A Veterans Day Parade is held annually in Shippensburg. The first Veterans Day was proclaimed by President Wilson on November 11, 1919, to honor veterans of World War I. Temporary cessation of hostilities between the Allied nations and Germany went into effect on the eleventh hour of the eleventh day of the eleventh month.

Shippensburg University

The Borough of Shippensburg is home to Shippensburg University. Formerly the Shippensburg State College, it was founded in 1871 as a Normal School to educate teachers. Old Main is the original building that was erected in 1871 when the college was founded. Fashion archives with apparel dating from the 1800s is a feature of interest here. Horton Hall was built in 1895. The four-story Romanesque style building served as the women's dormitory from 1898-1979. The Potato Point School/Mount Jackson School (one-room schoolhouse) was originally built in 1865 and was relocated to Route 696 just north of King Street. It preserves part of America's educational heritage and is run by the University. The Free Public School Act of 1834 increased the demand for teachers. Founded were the Shippensburg Academy in the 1840s, Shippensburg Institute in 1849, and Shippensburg Collegiate Institute in 1857, but each failed financially. A Normal School operated in Newville from 1857-1860. The Cumberland Valley State Normal School was founded and operated at Shippensburg 1871-1927. It was known as Shippensburg State Teachers College from 1927 to 1960, Shippensburg State College 1960 to 1983, and since then has been known as Shippensburg University.

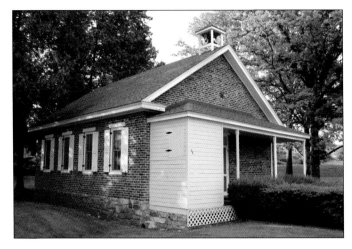

Potato Point School, c. 1865.

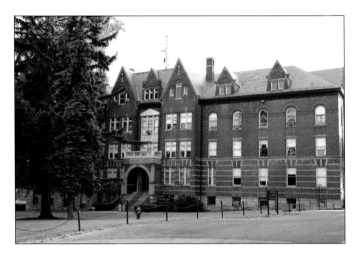

Horton Hall, c. 1895.

Old Main, c. 1871.

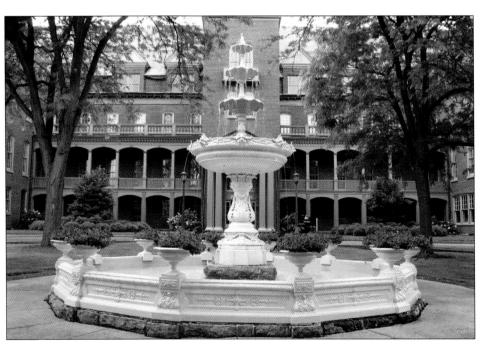

Fountain and Old Main at Shippensburg University.

Shippensburg Landmarks

WIDOW PIPER'S TAVERN/OLD COURTHOUSE, located on Route 11 at King and Queen Streets: The 2½-story irregular stone home has a one-story kitchen attached. Built in 1735 by Samuel Perry, it was originally a tavern run by Widow Janet Piper. Piper's tavern license in 1750 is the earliest existing license in Cumberland County. She was still running the tavern in 1753 when she was indicted for keeping a tippling house (operating a tavern without a license). Court sessions were held here in a second-floor room at the front for Cumberland County (1750-1751) until the courthouse was erected in Carlisle. It continued as a tavern, then was a residence, and is currently home to the Shippensburg Civic Club. James Burd, Edward Shippen's son-in-law, stayed at this inn when he first came to town.

THE BURD HOUSE, Britton Road, a half-mile from Queen Street: James Burd constructed this home in 1752 upon his move from Philadelphia. His wife, Sally, was the daughter of Edward Shippen. The home is privately owned. Burd's Run, the meadow and creek area, is a site where the earliest settlers lived.

Burd House, c. 1752.

Widow Piper's Tavern, c. 1735.

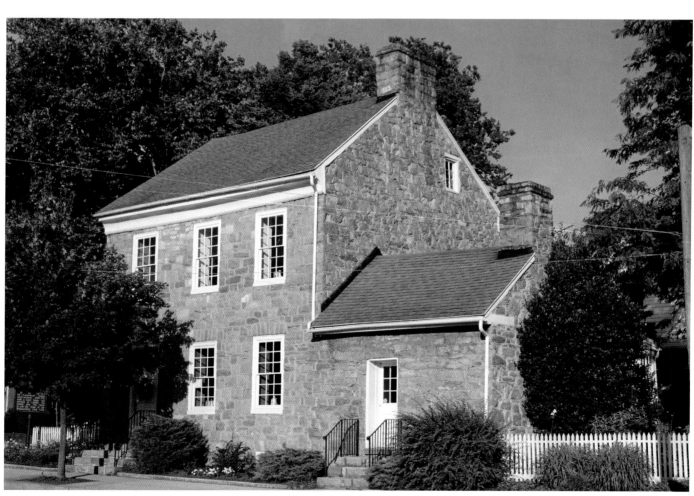

Shippensburg Historical Society/Dr. Alexander Stewart House, 52 West King Street: This 2½-story eighteenth century limestone and brick mansion is listed in the National Register of Historic Places. It was built in three sections, with the first part built circa 1750 by Edward Shippen. In 1785, a two-bay section was added to the western gable. The final addition was in the early nineteenth century. It was restored in 1935. Edward Shippen was the Mayor of Philadelphia and one of the founders of Princeton University. He acquired 1,300 acres in 1737, and laid out the town of Shippensburg in 1741. He lived in Lancaster and used this house periodically on visits to his trading companies. Legend has it this was the strong stone house that Shippen offered to Governor Morris in 1775 as a store house for the Braddock Expedition. The historical society was founded in 1945; exhibits include Indian arrowheads, pottery, history of Shippensburg from its founding in the 1730s, and the medical collections of Dr. Alexander Stewart.

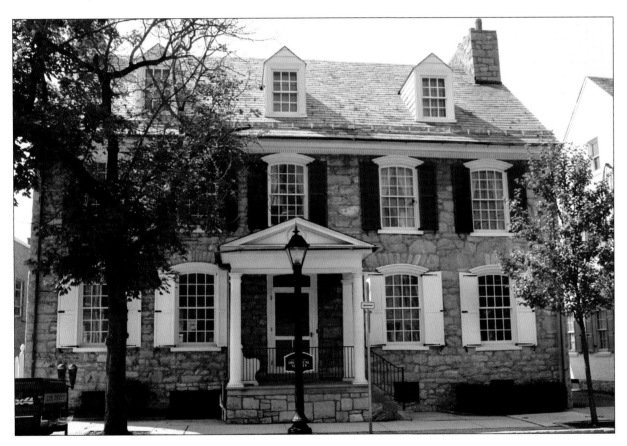

Dr. Alexander Stewart House, c. 1750.

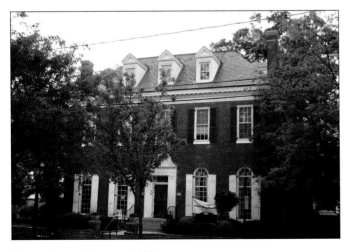

George Stewart House, c. 1880.

Shippensburg Public Library/historic George Stewart House, 73 West King Street: The Victorian/Second Empire style home was completed in 1880. It was remodeled in the Georgian Revival style in 1936 by George Stewart, Jr. and his wife, Dorothy. In 1957, it was purchased from Mrs. Stewart and remodeled for the library. This was the site of the former Rippey's Tavern/Black Horse Tavern where George Washington stopped during the Whiskey Rebellion for lunch.

PAGUE & FEGAN HARDWARE, 35 W. King Street, est. 1856: On June 23, 1863, the then McPherson & Cox's Hardware Store owners (John McPherson and wife Martha) hid their most valuable merchandise in the fireplaces in their home next door by covering the fireplaces with wallpaper. The Confederates never discovered the hidden fireplaces during the Civil War when they were obtaining supplies here on their quest to move toward and capture Harrisburg. A hardware store has since continuously operated at this location, making it Pennsylvania's oldest continuously operating hardware store and Shippensburg's oldest business.

GEORGIAN HOUSE, 20 W. King Street: This Greek Revival was built circa 1831. It was the boyhood home of Civil War Union General Samuel Davis Sturgis, hero of the Burnside Bridge in the 1862 Battle of Antietam. It was a private residence until commercial businesses were established in 1925. It is currently home to an art and collectibles shop.

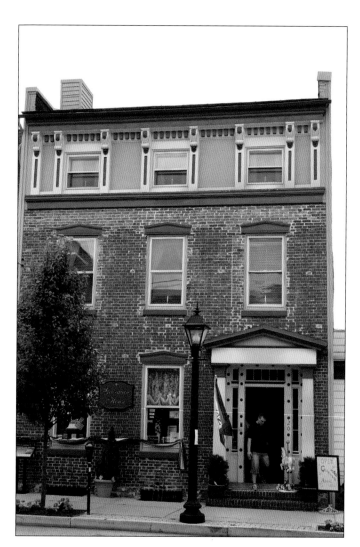

Georgian House, c. 1831.

Pague & Fegan Hardware, c. 1856.

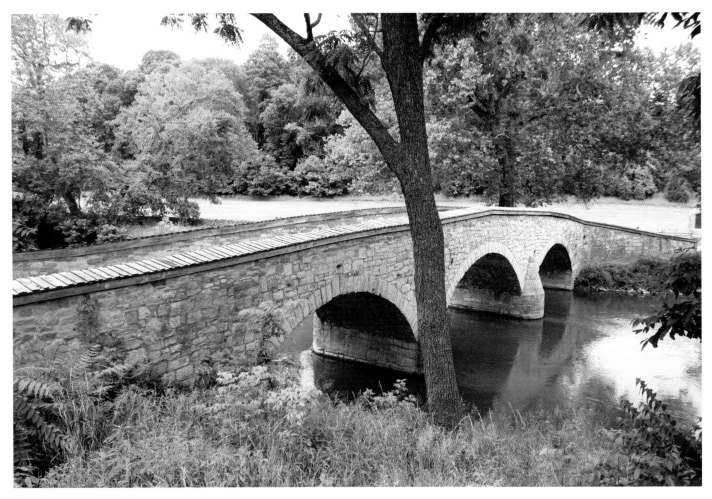

Burnside Bridge, circa 1836.

BURNSIDE BRIDGE: Built in 1836 of limestone and granite over Antietam Creek, the bridge was originally called the Lower Bridge and Rohrbach's Bridge before being renamed for Major General Ambrose Burnside, commander of Union troops that stormed the bridge under withering Confederate fire. Shippensburg native, Union General Samuel Davis Sturgis, was also a hero in the Battle of Antietam. This is one of the most photographed bridges of the Civil War and has been restored to its original condition.

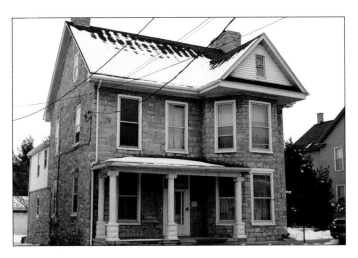

Sign of the Spread Eagle Tavern, c. 1780.

SIGN OF THE SPREAD EAGLE TAVERN, 427 E. King Street: In this circa 1780s, two-story stone home, tavernkeepers were Robert Porter (1789-1824) and Stephen Cochran (1825-1842). In 1800, Robert Porter was acquitted in the murder of his servant, Barnabus Duffy, whom he struck after a Regimental Review.

McLean House, 80 West King Street: Built in 1798 by Joseph Duncan, alterations were done in 1875 by James McLean. Re-enactors are shown here dressed in Victorian era clothing for the March to Destiny event.

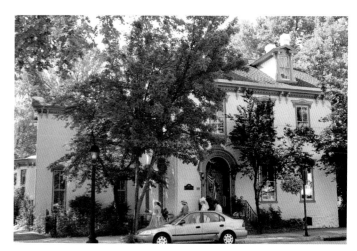
McLean House, c. 1798.

Middle Spring Presbyterian Church steeple.

Middle Spring Presbyterian Church, Middle Spring Road: From King and Earl Streets, go north on Route 696 for two miles and then turn left onto Middle Spring Road — the church will be on right. The first church (building) was one of the earliest churches in the valley, a log building erected in 1738. The current brick building was built in 1847. The cemetery is enclosed by a stone wall, with soldiers buried here from the French and Indian War, Revolutionary War, War of 1812, and Mexican War. The monument was dedicated in 1904.

Monument in Middle Spring Presbyterian Church yard was dedicated in 1904.

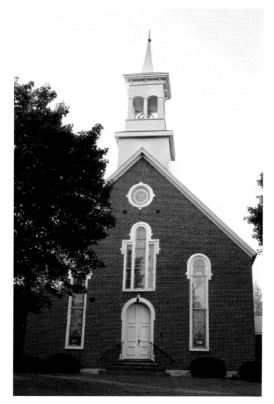
Middle Spring Presbyterian Church, c. 1847.

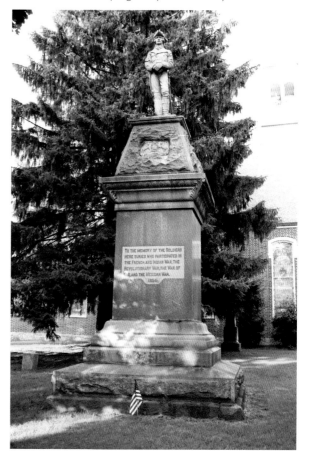

DYKEMAN HOUSE, 6 Dykeman Road: Built in 1861, it is listed on the National Register of Historic Places. Today the house sits on four acres of a once 450-acre estate established in 1740. In 1870, George Dykeman transformed the farmhouse into an Italianate Manor. This is the site of the town's first in-house hot and cold running water system. It is currently a bed and breakfast.

Located beside the house is Dykeman Spring, or Indian Head Springs, once home to the Delaware Native Americans. In 1863, Confederates marched through the streets and an encampment of 20,000 Confederate troops was established here just days before the Battle of Gettysburg. They were following the Cumberland Valley Railroad from Hagerstown to Harrisburg. The stone building was a fish hatchery built by George Dykeman.

Dykeman House, c. 1861.

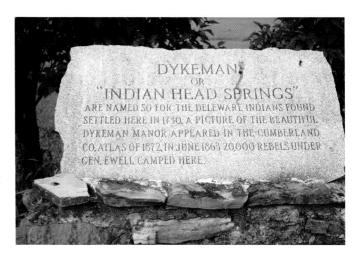

Indian Head Springs and encampment of Confederate soldiers marker.

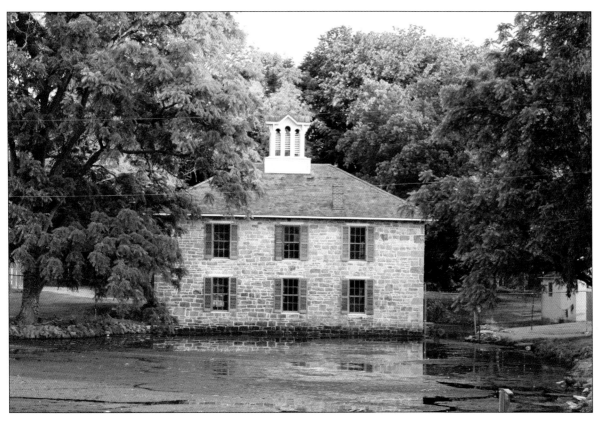

Dykeman Spring Fish Hatchery.

Peace Garden, Memorial Park

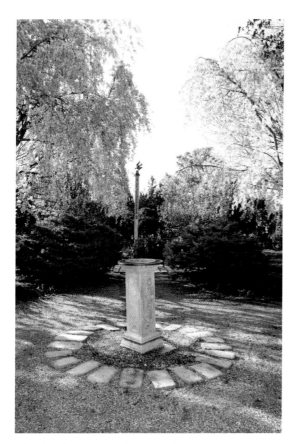

Weeping cherry trees in Peace Garden.

Flowering cherry trees in Peace Garden.

Weeping cherry trees in Peace Garden.

Chambersburg

The town was founded by Benjamin Chambers. Memorial Square is also known as The Crossroads of the Country because Route 11 extends from New York to Louisiana and Route 30 from the East Coast to the West Coast. On April 2, 1757, William McKinley and his son were killed and scalped by Indians. They sought shelter with the family at Chambers Fort, and were discovered by Indians on the creek when they ventured out to visit their dwelling and plantation.

James Buchanan, 15th President of the United States, was born near Mercersburg in 1791. President George Washington spent the night at The Morrow Tavern, Route 11 by Queen Street, on October 12, 1794.

Chambersburg was a major stop along the Underground Railroad before the Civil War. John Brown planned his raid on Harpers Ferry while staying in Chambersburg. Confederate forces came to town in 1862, 1863, and on July 30, 1864, when they burned the town, destroying 537 buildings and leaving more than 2,000 people homeless. A Memorial Marker stands in front of the bank at the Square depicting the burning of the town. In 1893, a time capsule was installed in the base of the marker.

In October 1862, Commander J.E.B. Stuart raided Chambersburg with 1,800 men looting supplies and food. Weapons were destroyed and local stores and railroad facilities were burned.

On June 15, 1863, President Abraham Lincoln reacted to the crossing of the Mason-Dixon Line by issuing a proclamation, which called the Pennsylvania militia into the national service. The two-day raid was directed by Brigadier General Albert Gallatin Jenkins, who rode north through Chambersburg to Scotland where he burned a bridge to hamper the ability of the defenders to reinforce any troops they might send via the Cumberland Valley Railroad. Within forty-eight hours, two regiments were in Harrisburg; within ten days of that, it increased to twenty regiments totaling 12,091 men. It was reported that the enemy was advancing in three columns: one towards Waynesboro and Gettysburg, one directly to Chambersburg, and one directly towards Mercersburg and the Cove Mountains.

On June 22, 1863, Jenkins and the infantry components of Ewell's Corps started up the valley again. Outside of Greencastle, he encountered Captain William H. Boyd; Boyd took casualties, including Pennsylvania Corporal William F. Rihl, the first man to die in the invasion.

By June 23, 1863, the Confederates were re-entering Chambersburg with a band playing "Bonnie Blue Flag." Following the band was General Ewell, accompanied by Mary Lincoln's brother, Major Todd, of the Confederate Army.

In 1863, Confederates went through Chambersburg en route to Gettysburg under Confederate General Richard S. Ewell. He came across the Caledonia Iron Works foundry owned by U.S. Representative Thaddeus Stevens and ordered the entire complex be sacked. Just days before the Battle of Gettysburg, Confederate General Robert E. Lee and Confederate General A.P. Hill met in the square to discuss advancement towards Gettysburg or Harrisburg. On June 26, 1863, east of town, camped 70,000 Confederates.

On July 30, 1864, Confederate Brig. General John McCausland demanded heavy ransom for Confederate General Jubal Early, and if refused, McCausland threatened to torch the town. One man was killed, 550 structures destroyed, and more than 3,000 people lost their homes when the town's fathers refused to pay the ransom to the Confederates. These acts caused Franklin County to suffer more southern incursions than any other area north of the Mason-Dixon Line.

The Cedar Grove Cemetery, between N. Franklin and Hood Streets, is where many families found refuge after the Great Fire in 1864. Three children were born here. Buried here is the oldest man to live in Pennsylvania, John Hill, who died at the age of 128 in 1832. Also buried here is Thomas Jefferson's great-great-grandson, Nicholas Browse Trist, as well as soldiers from the Battle of Antietam.

Other interesting facts about Chambersburg are:
• Wilson College, a private Presbyterian-affiliated college to educate women, opened in 1869.

• Dr. Benjamin Senseny developed the first commercial production of the smallpox vaccine in the world at 152 Lincoln Way East, now a parking lot. Dr. Senseny died at age thirty-seven in 1880.

• Babe Ruth and Lou Gehrig played baseball here when the New York Yankees played the Chambersburg Yankees at Henninger Field, Vine Street and Strealey Alley.

• Caledonia State Park is a 1,125-acre park located between Chambersburg and Gettysburg, offering picnic tables, hiking trails, fishing, swimming, and camping. Named for Thaddeus Stevens' charcoal iron furnace, Caledonia was founded in 1837. During the Civil War in 1863, the Confederates destroyed the iron furnace. Caledonia was used as a field hospital for soldiers wounded in the Battle of Gettysburg. A trolley ran through the day-use area in the early 1900s. In 1927, the Pennsylvania Alpine Club reconstructed the stack of the old furnace.

• Nellie Fox was born in 1927 in Franklin County. He is in the Baseball Hall of Fame.

• Benjamin Franklin Mahoney was a member of Mercersburg Academy's class of 1918. He helped to build the "Spirit of St. Louis" airplane that carried Charles Lindbergh from New York to Paris in 1927. Actor James Stewart portrayed Charles Lindbergh on film. Stewart made his stage debut at Mercersburg Academy where he graduated in 1928.

• The Totem Pole Playhouse has been providing shows since 1950.

• In 2009, Chambersburg was ranked sixteenth in *Newsmax* magazine as one of the twenty-five cities and towns that best express our National values. Chambersburg also ranked twelfth in the U.S. on *Bizjournal's* list of "Dream Towns" because it is a "small American town that offers the highest quality of life."

• *Allegheny Uprising* was a film featuring John Wayne depicting a skirmish that occurred ten years before the Revolutionary War.

Hummingbird feeding in a garden of bee balm, Sinnemahoning State Park.

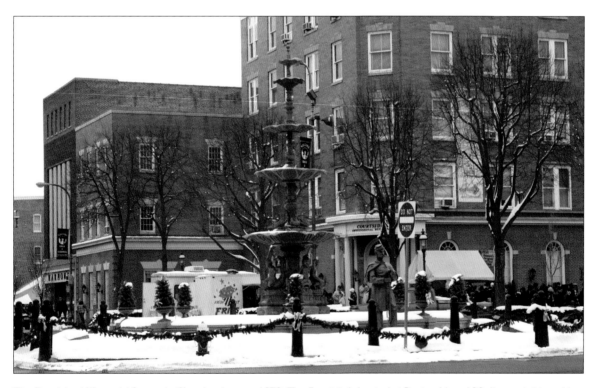

The Fountain at Memorial Square in Chambersburg, c. 1878. The Fountain is located at Routes 11 and 30. It was christened in July 1878 to honor soldiers who fought and fell during the Civil War. On the south side of the fountain is a Union soldier statue facing south to guard against the return of the Confederates.

Chambersburg Landmarks

CHAMBERS' FORT, West King Street: Erected in 1756 by Col. Benjamin Chambers to defend his property with firearms, swivel canons, and blunderbusses. Inside were his private residence, a saw mill, and a grist mill. The Falling Spring Creek maintains a year-round water temperature of 52 degrees.

Founding Family Statue, also known as The Homecoming statue, is of Benjamin Chambers welcoming home his son, James, and grandson, Benjamin, after six years in the Revolutionary War. Chambersburg is named after this family.

Chambers' Fort, c. 1756.

The Homecoming Statue of Chambers family.

CENTRAL PRESBYTERIAN CHURCH AT THE SQUARE, 40 Lincoln Highway West: Organized in 1868, the 186-foot steeple was erected during the church's construction in 1869, making it the tallest building in Chambersburg.

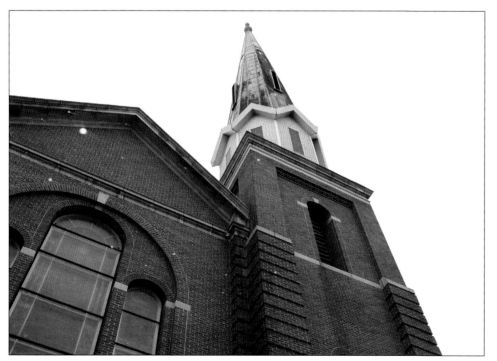

Central Presbyterian Church, c. 1868.

FRANKLIN COUNTY COURTHOUSE AT THE SQUARE, 157 Lincoln Highway East: Built in 1842 and burned during the Great Fire of 1864, it was reconstructed. The fiberglass statue of Benjamin Franklin overlooks the courthouse. Franklin County is named after Benjamin Franklin. An original wood statue from 1865 was removed in 1991, and is now on display in the Heritage Center.

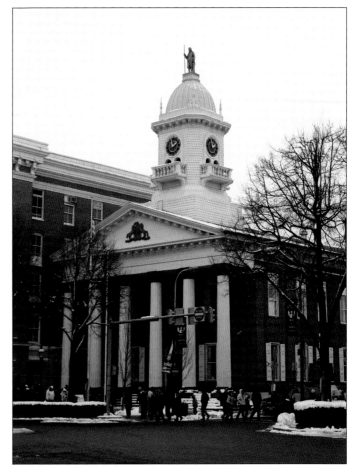

CHAMBERSBURG HERITAGE CENTER AT THE SQUARE, 100 Lincoln Way East: Built in 1915 entirely of marble inside and out to prevent being burned, the center now features historical displays of the county, including the Civil War, Underground Railroad, famous Franklin County residents, and more. Explore history in this beautiful building.

Franklin County Courthouse, c. 1842.

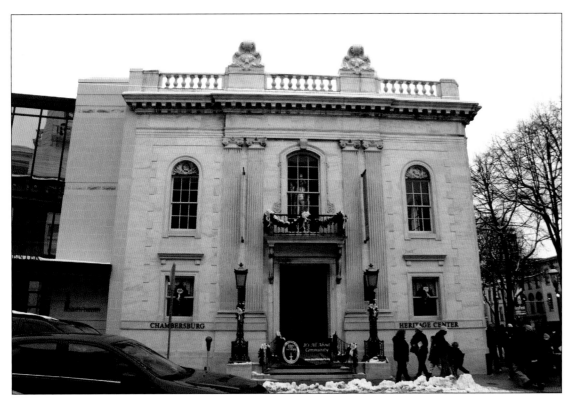

Chambersburg Heritage Center, c. 1915.

THE FIRST CHAMBERSBURG HOSPITAL, 217 S. Main Street: The first patient admitted to the first public hospital in Chambersburg was on September 24, 1895. This was previously the residence of Dr. A. H. Sensensy, father to Benjamin Sensensy who developed the first commercial vaccine virus for smallpox in the United States.

ZION REFORMED CHURCH, Route 11 and East Liberty Street: This church survived the Great Fire of 1864. Inside is a chandelier built in 1813. From the spire, a panoramic view of Chambersburg was sketched by W. W. Denslow, the famous illustrator of *The Wizard of Oz*.

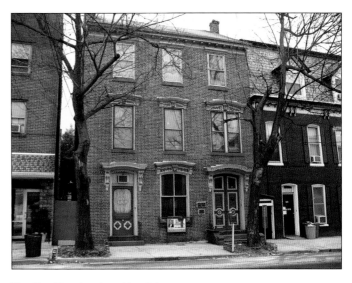

The First Chambersburg Hospital.

LINCOLN HIGHWAY MARKER, along Lincoln Way and Third Street: Markers with the print of Abraham Lincoln's head were placed by the Boy Scouts every mile from New York City to San Francisco. Only a few of the markers remain.

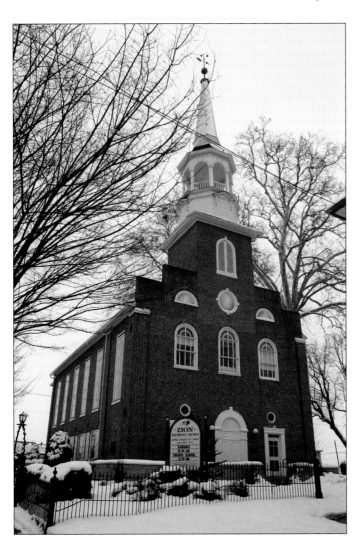

Zion Reformed Church, c. 1813.

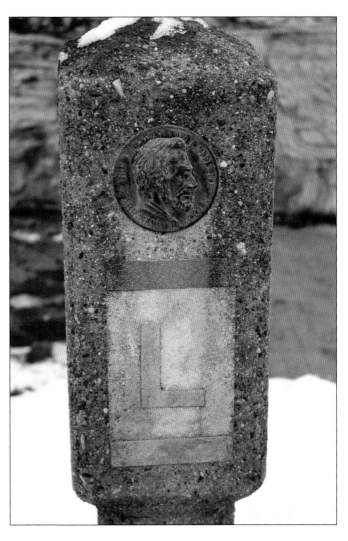

Lincoln Highway Marker.

Dr. Suesserott's House, Route 11 and Washington Street: Built in 1807, this Flemish Bond brick was home to Jacob Lewis Suesserott, M.D., a doctor, dentist, and surgeon during the Civil War. The Great Fire of 1864 stopped just before this house, sparing it. It has been said that Dr. Suesserott met with Robert E. Lee in 1864 to get back a neighbor's horse that was stolen by the Confederates.

Dr. Suesserott's House, c. 1807.

The Old Jail, Second and West King Streets: The oldest jail in Pennsylvania is still standing. The Georgian architecture building was built in 1818, and had the longest continuous use until 1971. The sheriff resided on the left side of the building with his family. It was part of the Underground Railroad. In the courtyard are the gallows that were used for hangings until 1912. The building survived the Great Fire of 1864. It is currently the Kittochtinny Historical Society, which houses a former Chambersburg Hospital operating table and mantel from the John Brown House. It was listed on the National Register of Historic Places in 1970.

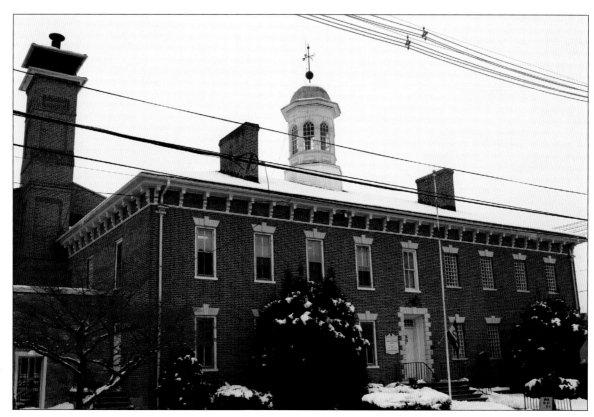

The Old Franklin County Jail, c. 1818.

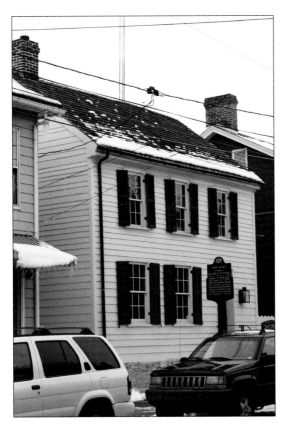

Mary Ritner/John Brown House.

JOHN BROWN HOUSE, West King Street and Harrison Avenue: Also known as Mary Ritner's Boarding House, it was a stop on the Underground Railroad. Ritner was a strong supporter of northern abolitionists. In 1859, John Brown met with Frederick Douglass in planning a raid on Harper's Ferry, which was not successful. Brown stayed here under the pseudonym Isaac Smith. Brown was hanged in 1859 for treason. The house is on the National Register of Historic Places, and is open to the public through the Kittochtinny Historical Society.

CHAMBERSBURG FIRE MUSEUM, Broad Street: This is the former headquarters of Cumberland Valley Hose Company No. 5. Joseph Richard Winters received a patent for his fire escape ladder in 1882. Winters was an African American inventor who resided in Chambersburg and was active in the Underground Railroad.

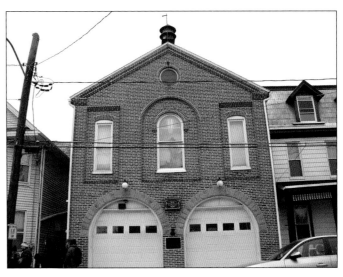

Chambersburg Fire Museum.

SELLER'S FUNERAL HOME, Route 11 near Chambers Street: Built in 1782 by Dr. Calhoun, the limestone is the oldest private residence in Chambersburg; it contains 23-inch thick walls. Dr. John C. Calhoun was the first physician in town, and was married to Benjamin Chambers' daughter. Benjamin Chambers died here on February 12, 1788.

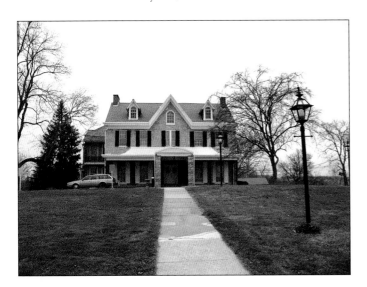

Dr. John C. Calhoun House, c. 1782.

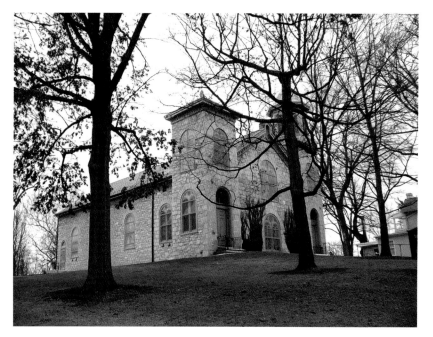

FALLING SPRING PRESBYTERIAN CHURCH, Route 11: The church was established in 1734. Benjamin Chambers gave the land for the church to be built in 1768. The only payment Chambers requested was a rose to be presented as rent each year to Chambers' family descendants — and to this day a rose is still given to a descendant. Behind the church is the Falling Spring Presbyterian Church Cemetery, which includes the marble stone grave of Benjamin Chambers, many notable citizens from the eighteenth century, and also Delaware Indian Tribe Native Americans.

Falling Spring Presbyterian Church, c. 1734.

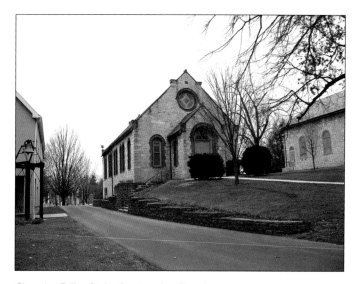

Chapel at Falling Spring Presbyterian Church.

Chambers family graves.

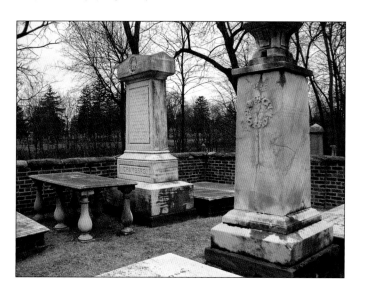

Beautiful Ice Sculptures

Ice sculptures are created by artisans at the IceFest in downtown historic Chambersburg, held annually the last week in January.

Snowman ice sculpture.

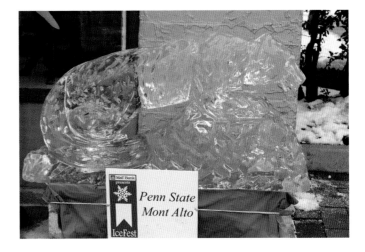

Penn State Nittany Lion ice sculpture.

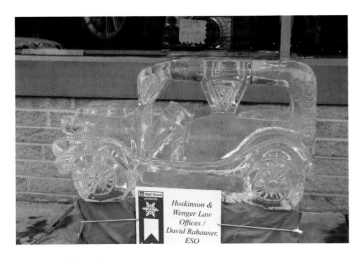

Antique car ice sculpture.

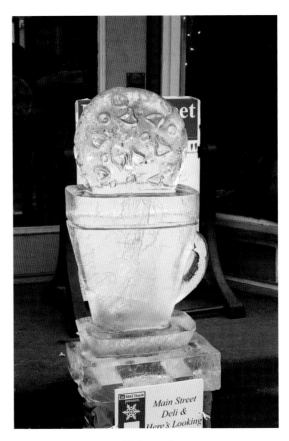

Cup of coffee with a cookie ice sculpture.

Perry County

The land was previously occupied by Native American tribes and nations as they migrated from the increasing number of European settlers. The Albany Purchase of 1754 acquired the land from the Iroquois League of Six Nations. On October 15, 1755, a party of Native Americans fell upon inhabitants at Penn's Creek. They killed and scalped twenty-five men, women, and children and destroyed their buildings, leaving the whole settlement deserted. The first settlers were generally Scotts-Irish who came over the mountains from Carlisle and Conococheague settlements.

Around 1840, a water-powered gristmill was built. Shoaff's Mill operated until 1940. There are many streams in the county. The Warm Springs waters in the Blue Mountains were known to have had some medicinal properties and healing virtues. Sheriff John Hipple leased land from James Kennedy and erected a boardinghouse at the Springs for the enjoyment of the luxury of the bath.

Perry County was part of Cumberland County until March 22, 1820. It was named after War of 1812 hero, Oliver Hazard Perry. The County Seat is New Bloomfield, incorporated in 1831. The first Court of Common Pleas was held in Landisburg in 1820. It was the birthplace of numerous governors — one of California, two of Pennsylvania, and one of Minnesota.

During the Civil War, Union Major General Darius N. Couch ordered units into Perry County for picket duty at the railroad bridges. Hundreds of city boys, including the fanatic Boston Corbett (who later shot John Wilkes Booth), marched and slept in Perry County.

On December 26, 1941, a fatal aviation accident occurred north of Route 17 between Blain and Kistler on the Conococheague Mountain above Stony Point.

Perry County is home to Little Buffalo State Park on State Park Road between New Bloomfield and Newport. The only full-service state park in the county, it includes the 88-acre Lake Holman for boating, fishing, ice fishing, and ice skating. It opened to the public on June 11, 1972.

Musa Smith, a West Perry High School graduate, played professional football for the Baltimore Ravens.

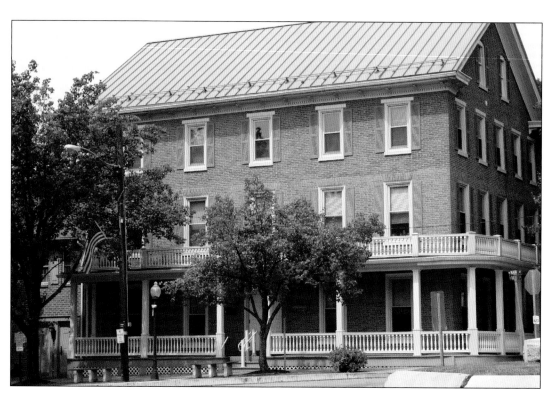

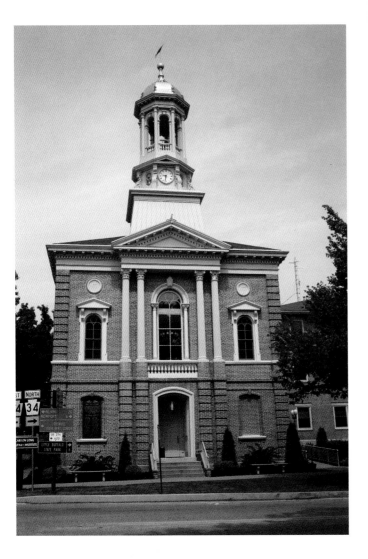

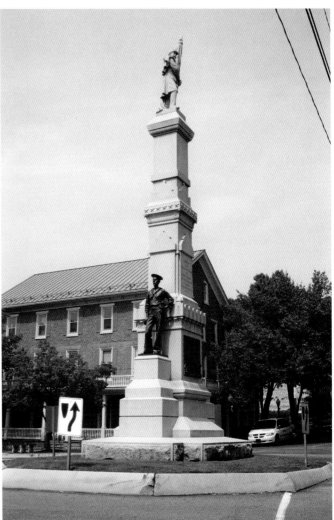

New Bloomfield is the county seat of Perry County. Above and on the previous page are the Rhinesmith Building, c. 1836, formerly the original site of the Bloomfield Academy, the forerunner of Carson Long Military Institute. It was moved two blocks north in 1840 to its present location. The Perry County Courthouse (left) is located at One East Main Street. The monument at the center of the square was erected in 1898."

Located at 136 Main Street, this quaint white two-story home with a white picket fence once belonged to my grandparents, William Joseph and Elsie Stine Lebo.

The *Perry County Times* was once owned by my great-grandparents, William Coffey and Annie Catherine Lebo.

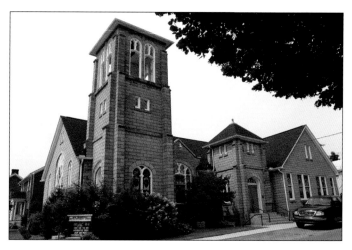

New Bloomfield United Methodist Church on Main Street.

Perry County Landmarks

SHOAFF'S MILL, LITTLE BUFFALO STATE PARK: Constructed in the mid-1830s by James McGowan and John McKeehan, the mill was sold to William H. Shoaff in 1849. In 1861, Shoaff built the brick house across the road. The mill was used to grind wheat and buckwheat flours, cornmeal, and feed for livestock until the 1940s. It was restored by Little Buffalo State Park staff after being purchased in 1966 by the Commonwealth of Pennsylvania.

Lake Holman at Little Buffalo State Park.

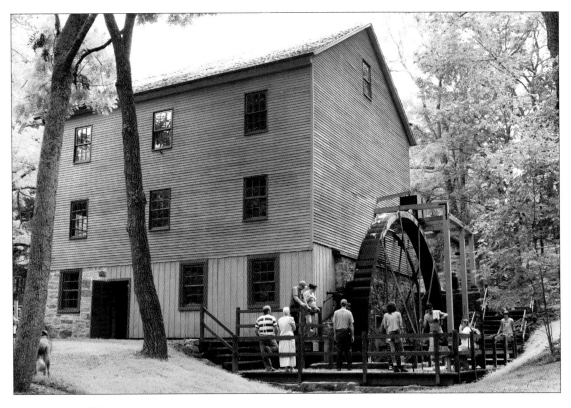

Shoaff's Mill, c. 1830.

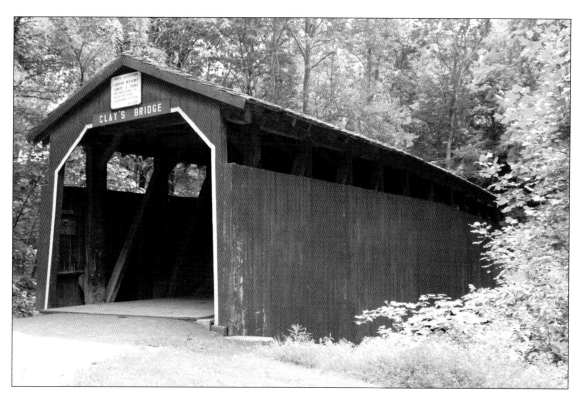

Clay's Bridge near
Shoaff's Mill.

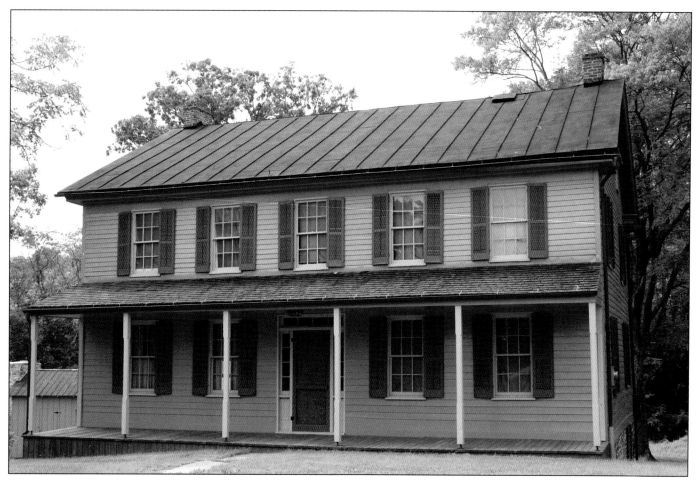

Blue Ball Tavern, c. 1811. Today, it's the Historical Society of Perry County building near Shoaff's Mill, but it was known as the historic Blue Ball Tavern from 1811-1841. Military messengers stopped here during the War of 1812.

AIRY VIEW SCHOOL HOUSE, Route 34 between Newport and New Bloomfield: Now home to The Perry Historians and Harry W. Lenig Library, the bell on display outside was donated by Neil I. and Doris Lightner, and was presented by the citizens of Spruce Bank Sub. School District in 1896.

Bell at The Perry Historians, presented in 1896.

Airy View School House.

BLAIN, PENNSYLVANIA: The first settler of Blain was James Blaine of Londonderry, Ireland, in 1763. Blain was incorporated as a borough in 1877. Zion's Evangelical Lutheran Church at Church Alley and Blain Road was built in 1898.

The Newport & Shermans Valley Depot in Blain was restored by the Blain Lions Club in 1985 and is now open to the public. The railroad was in operation from 1890 to 1935, and ran from Newport to New Germantown.

Enslow Bridge, located on Adams Road, Blain, was built in 1904.

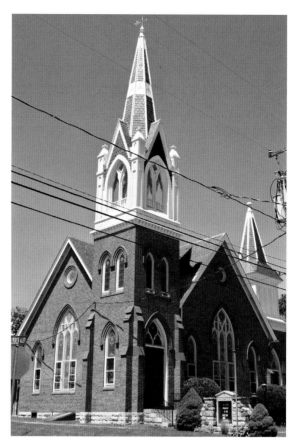

Zion's Evangelical Lutheran Church, c. 1898.

Blain historic sign.

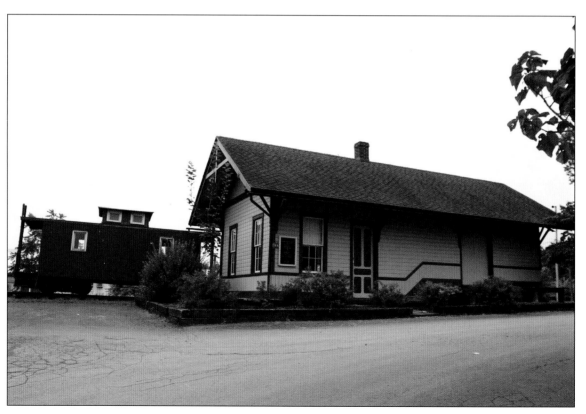

Newport & Shermans Valley Depot, Blain, Pennsylvania.

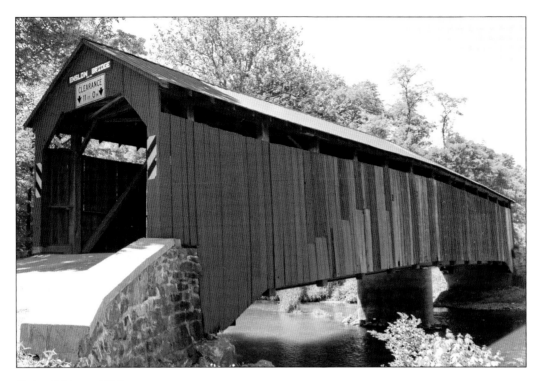

Enslow Bridge, c. 1904.

ROCKVILLE BRIDGE, U.S. Routes 11 and 15 at north end of Marysville: This bridge connects Marysville, Perry County, with Harrisburg, Dauphin County, over the Susquehanna River. Built in 1900-1902, it is the longest stone masonry arch railroad bridge in the world. It has forty-eight arches and is 3,820 feet long. Previously constructed here were a wooden bridge built in 1847-1849 and an iron bridge in 1877.

Rockville Bridge, c. 1900.

Harrisburg

Pennsylvania was named by King Charles II in honor of the son of Giles Penn (and William Penn's father), Sir William Penn, an Admiral in the English Navy. The William Penn family visited Pennsylvania in 1699 and remained until 1701 when he sailed to England and never returned. A deed dated October 11, 1736, to the Penn heirs was signed by the Native American chiefs of Onondaga, Seneca, Oneida, and Tuscorora nations, granting to the Penns all land along the Susquehanna River on both sides.

Harrisburg has been the capital of Pennsylvania since 1812. The town was laid out in 1785 by John Harris, Jr. The Susquehanna River is dotted with numerous green islands, and City Island is utilized for entertainment and parking.

In 1861, Abraham Lincoln visited the state capitol at Harrisburg where he expressed his pre-war hope that local militia would never have to shed fraternal blood to save the nation. Lincoln then boarded a train to Philadelphia, traveling southward through Baltimore to Washington, in secrecy to avoid any assassination threat.

Harrisburg was a stopping place on the Underground Railroad for escaped slaves traveling north towards Canada. It was also a significant Union Army training center during the Civil War, with thousands passing through Camp Curtin, the most permanent and substantial camp established during the Civil War. Camp Curtin sprawled over about six blocks of land, and was commanded by a colonel who later became Governor James A. Beaver. Harrisburg was the target of Confederate General Robert E. Lee's Army of Northern Virginia in 1862, after taking Harper's Ferry, and during the Gettysburg Campaign in 1863, but the decisive battle of the war would end up being fought in Gettysburg instead of Harrisburg.

In 1863, the South's main objective was to seize Harrisburg, a supply and transportation hub for the Union, but Union forces reacted quickly and prompted Lee to consolidate his army at a centralized point. This

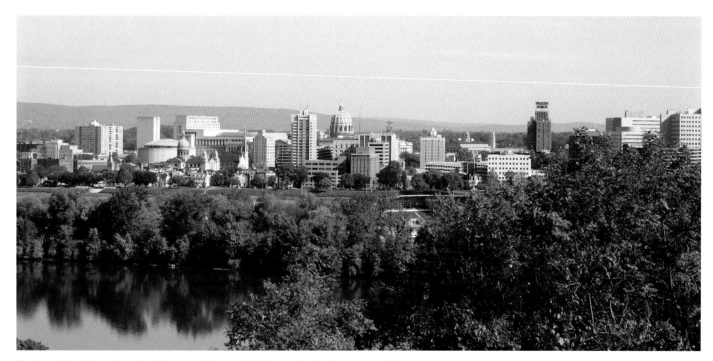

Skyline of Harrisburg, Dauphin County, and the capital of Pennsylvania. The state capitol building was built in 1906 and is one of the most beautiful in the country.

changed the original plan of an attack on Harrisburg to a battle being fought in Gettysburg. Confederate forces advanced from Hagerstown, Maryland, along the railroad to the Susquehanna River near Harrisburg by the end of June 1863.

On June 12, 1863, a newspaper proclamation was made by Pennsylvania Governor Andrew G. Curtin that a large Rebel force was prepared to make a raid into Pennsylvania. The President erected two departments: one in eastern Pennsylvania, to be commanded by Union Major General Darius N. Couch; the other in western Pennsylvania, to be commanded by Union Major General William Thomas Harbaugh Brooks. The proposed Corps would give security to the Pennsylvania border. Curtin urged people to respond to the call of the government and promptly fill ranks of these Corps to defend homes, firesides, and property from devastation.

On June 15, 1863, the Governor noted the State Capitol was in danger and ordered the bells rung, resulting in the people assembling en masse at the Courthouse to devise a means to defend the city. It was evident something needed to be done immediately or the State Capitol would be invaded. President Lincoln issued a proclamation calling upon Pennsylvania for 50,000 men to be paid by the U.S. He called upon the people of Pennsylvania capable of bearing arms to enroll in military organization, and encouraged all others to give aid and assistance to efforts for protection of the state and salvation of our common country.

Despite fighting small skirmishes within a few miles of Harrisburg, the majority of Lee's army never made it to Harrisburg. Learning of the approach of the Union Army, the Confederate Army canceled its effort to capture Harrisburg and concentrated toward Gettysburg in preparation for a showdown battle. If Harrisburg had been captured by the Confederates in 1863, it might have changed the outcome of the war and the future of America. On July 7, 1863, it was reported that the whole Rebel army was in an utter panic and fleeing in all directions, throwing away arms, abandoning guns, trains, and everything, in order to save their lives.

Other interesting facts about Harrisburg are:

• The Pennsylvania Farm Show has been held since 1917, and is the largest indoor agricultural exposition in the U.S.

• The Harrisburg Senators baseball team, first started in 1924, has been affiliated with the Pittsburgh Pirates, Montreal Expos, and Washington Nationals. The Harrisburg City Islanders are a professional soccer team that play on City Island (between the east and west shore).

• In June 1972, Harrisburg was flooded from the remnants of Hurricane Agnes.

• In 1979, the TMI Nuclear plant suffered a partial meltdown with over 140,000 fleeing the area after Governor Richard Thornburgh recommended evacuating pregnant women and preschool children that lived within five miles of the power plant.

• The films *Lucky Numbers, Girl Interrupted, The Distinguished Gentlemen*, and *Major League II* were filmed in Harrisburg. *Lucky Numbers* starred John Travolta and Lisa Kudrow in 2000, and was based on a 1980 lottery scandal with filming locations also in Carlisle, Mechanicsburg, Enola, Hershey, and Wormleysburg. Riverside Park served as the backdrop for the movie. Portions of the movie *Girl, Interrupted*, starring Winona Ryder and Angelina Jolie, were filmed at the former Harrisburg State Hospital in 1999. *The Distinguished Gentlemen*, starring Eddie Murphy, was filmed in 1992. The beautiful state capitol was the backdrop for this movie filmed in Harrisburg and Washington, D.C. *Major League II* was filmed in 1994, starring Charlie Sheen and Tom Berenger. Scenes were filmed at the baseball stadium on City Island with palm trees brought in for spring training ballpark scenes. Harrisburg scenes were also used in the television soap opera, *One Life to Live*.

• Harrisburg offers the Whitaker Center for Science and the Arts, located at 222 Market Street. The Harrisburg Symphony Orchestra holds concerts at The Forum, Fifth and Walnut Streets.

• Harrisburg is home to the National Civil War Museum, the only museum in the United States with the entire story of the American Civil War. Alcatraz, off the coast of San Francisco, California, was at one time a military prison during the Civil War. Confederate soldiers were the first prisoners at Alcatraz. Union soldiers were also imprisoned there. No more than thirty Civil War prisoners were held at Alcatraz at one time.

• The rock band, *Fuel*, first starting playing in Harrisburg establishments.

Harrisburg Landmarks

JOHN HARRIS/SIMON CAMERON MANSION, 219 S. Front Street: Built in 1764-66 at the end of the French and Indian War by the founder of Harrisburg, John Harris, Jr., the home belonged to Simon Cameron (1863-1869). Many famous people have visited there. Harrisburg was laid out in 1785 by Harris and his son-in-law, William Maclay. Simon Cameron acquired the property in 1863. Cameron was President Lincoln's first Secretary of War and was also the Minister to Russia. It has been home to the Dauphin County Historical Society since 1941. John Harris, Sr. traded with the Native Americans and established the river-crossing ferry. Harris, Sr., who was from Yorkshire, England, was a friend of William Penn, and father to John Harris, Jr. Harris, Sr. died in 1748, and is buried across the street from the mansion.

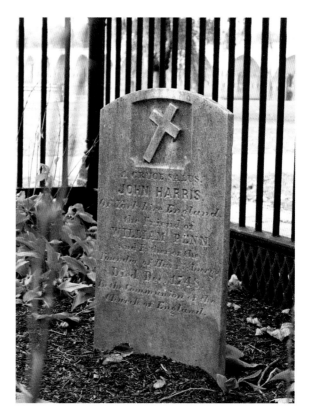

Gravesite of John Harris, Sr.

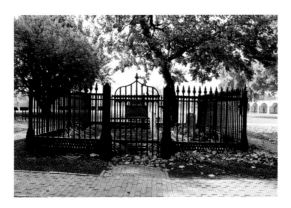

Burial site of John Harris, Sr.

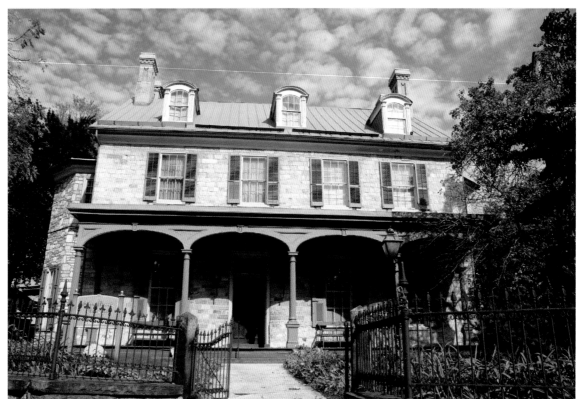

John Harris Mansion, c. 1764.

FORT HUNTER MANSION AND BARN, 5300 N. Front Street: The Susquehannock and Delaware Native American tribes first occupied this area. Benjamin Chambers originally settled here in 1725 and later became the founder of Chambersburg. Around 1750, Samuel Hunter settled here to run a grist mill with his wife, Catherine Chambers. A fort was built here in 1755 by the British to protect settlers from the Native Americans. The Federal style mansion was built in 1814 by Captain Archibald McAllister, a Revolutionary Army Officer who served directly under General George Washington. The barn, built circa 1876, housed John Reily's milk business and the Fort Hunter Dairy.

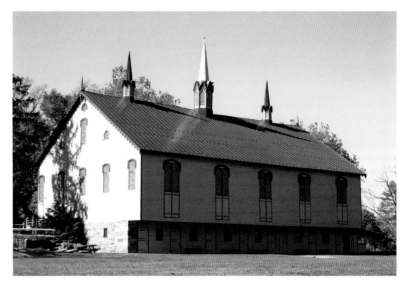

Fort Hunter Barn, c. 1876.

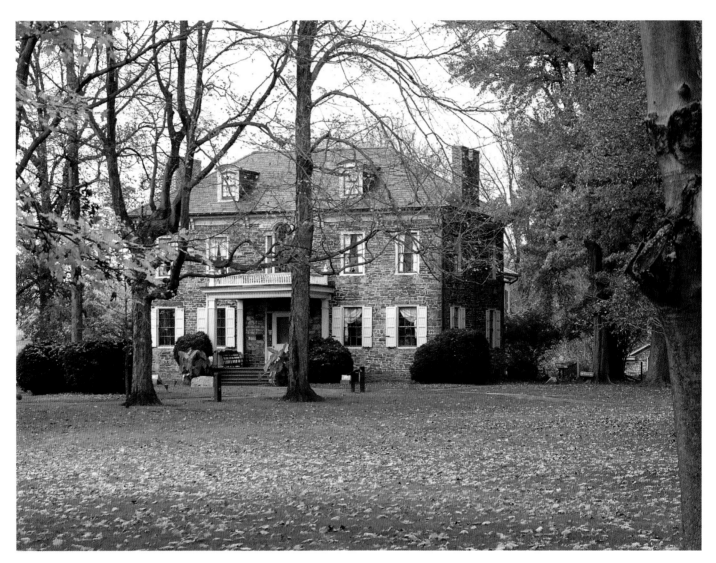

Fort Hunter Mansion, c. 1814.

STAR BARN, off Route 283 on Nissley Drive near Middletown: Built in 1872, it is listed on the National Register of Historic Places. The three-story barn has a limestone foundation.

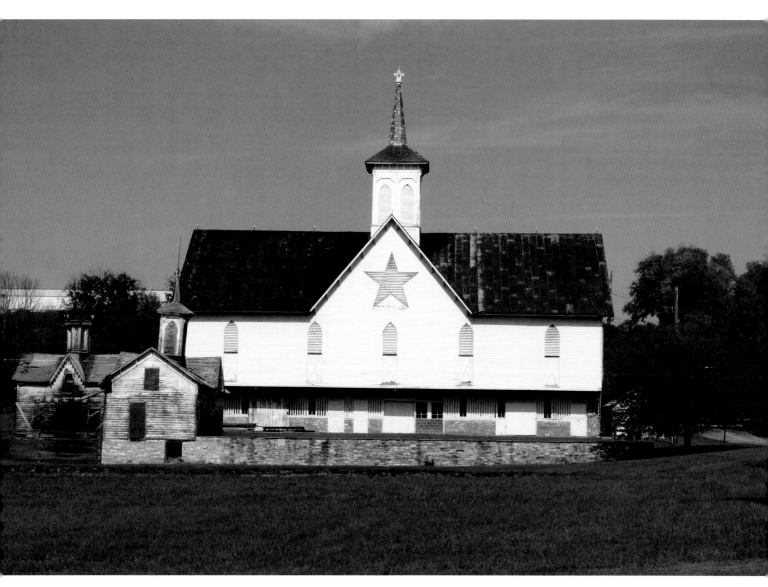

Star Barn, c. 1872.

THE NATIONAL CIVIL WAR MUSEUM, 1 Lincoln Circle at Reservoir Park: Opened on President Lincoln's birthday, February 12, 2001, the museum portrays the entire story of the American Civil War.

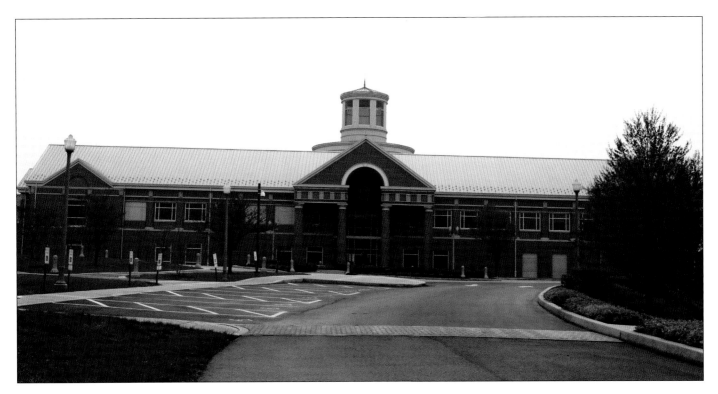

National Civil War Museum, c. 2001.

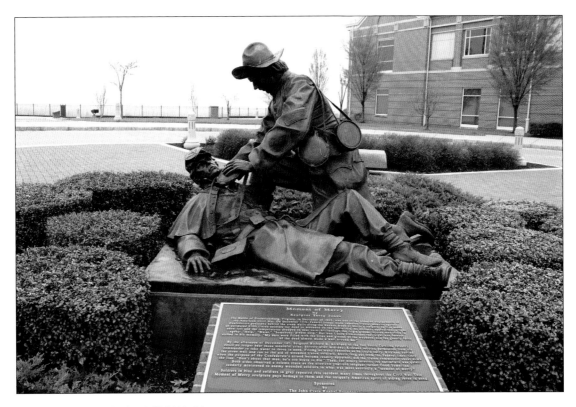

Statue of Soldiers at National Civil War Museum.

Hershey

This town was previously known as Derry Church before being renamed Hershey when the public suggested the name for the new post office in 1906. It is named for Milton S. Hershey, who enriched the lives of many locals and Americans. He was born in 1857 in Derry Township, Pennsylvania. He was first an apprentice to a local printer before making candy for a Lancaster confectioner. He opened his own candy shop in Philadelphia in 1876, but it failed. He later moved to New York City, where his second business collapsed. Hershey then made caramels in Lancaster that were a huge success throughout the United States and Europe.

Milk chocolate was a luxury product made only in Switzerland in the late nineteenth century, and Hershey desired to make chocolate affordable and experimented with making it in a wing of his caramel company. The Hershey Chocolate Company was incorporated in 1894. When milk chocolate was introduced in 1900, it became a fast success. His chocolate factory was completed in 1905 in Derry Church, now Hershey.

Milton S. Hershey desired to build a community that would nurture his workers. He benefited others with the development of the town, which included a boarding school for orphaned boys in 1909 and the Milton S. Hershey Medical Center in 1967. To create jobs during the Great Depression, he undertook major construction with the Hershey Community Building, the Hershey Community Theatre, the Hotel Hershey, the Hershey Industrial Junior-Senior High School, the Hershey Sports Arena, the Hershey Museum, a new office building for the Hershey Chocolate Corporation, and many new rides for Hershey Park. Hershey started the Hershey Junior College in the Hershey Community Building.

The Hershey Bears ice hockey team was founded in 1932. They have the most Calder Cup championships in the history of the American Hockey League. They have been affiliated with the Washington Capitals, Boston Bruins, Philadelphia Flyers, and Colorado Avalanche. They formerly played in the Hershey Sports Arena (c. 1936), which was the first of its kind

Fall mum flowers.

built in the U.S. with no visible means of support. The team was originally called the Hershey B'ars, with its name changed to the Hershey Bears when joining the American Hockey League. Milton Hershey's eightieth birthday was celebrated here. It was an evacuation site during World War II and Three Mile Island, and President Dwight D. Eisenhower celebrated his sixty-third birthday here on October 13, 1953. The Giant Center is now the Bears' home.

Hershey Theatre, 15 East Caracas Avenue, was designed after the grand and opulent style of Venice, Italy. Some performers at this venue include Katharine Hepburn, Bob Newhart, and Rex Harrison.

The town of Hershey and Hershey Park were designed by Oglesby Paul, who also designed Fairmount Park in Philadelphia. The town streets were named after cocoa-growing regions of the world: Areba, Caracas, Ceylon, Granada, Java, Para, and Trinidad. Homes were built by Milton Hershey's top executives along East Chocolate Avenue.

Hershey is home to the Milton S. Hershey Medical Center (c. 1967). In 1963, a donation of $50 million and one hundred acres was made for the Pennsylvania State University to build a medical school and hospital. In 1967, there were forty medical students here. The first hospital in Hershey was in a house on East Chocolate Avenue, the second was on the fifth floor

of the Hershey Community Building, and the third at the Hershey Industrial School in 1941.

The Antique Auto Club of America (AACA) Museum is located at 161 Museum Drive.

Milton Hershey was buried at the Hershey Cemetery on October 16, 1945, alongside his parents and wife.

Hershey Landmarks

DERRY PRESBYTERIAN CHURCH, 248 East Derry Road: Founded in 1724, the Derry Church (now Hershey) grove was patented by the sons of William Penn in 1741. The churchyard is the oldest pioneer graveyard in the region.

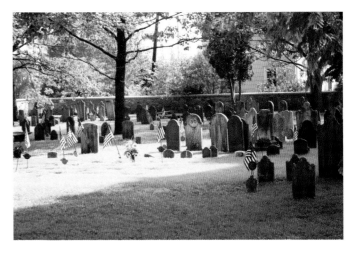

Pioneer graveyard at Derry Presbyterian Church.

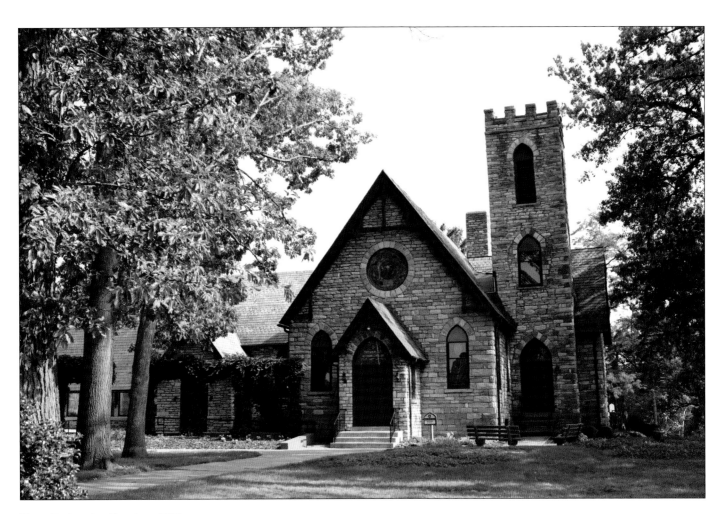

Derry Presbyterian Church, c. 1724.

MILTON S. HERSHEY MANSION (HIGH POINT), Mansion Road, Hershey: Built in 1913 for the home to Milton S. Hershey and his wife, Hershey started the Hershey Country Club and donated his Highpoint home for the clubhouse. The landscaping, flowerbeds, fountains, and grounds were open to visitors from the beginning. High Point is currently the home to The Hershey Trust Company offices. The Hershey Chocolate Company was built between 1903-1905. Hershey's Kisses® were introduced in 1907, and the Kiss street lights were placed in 1963.

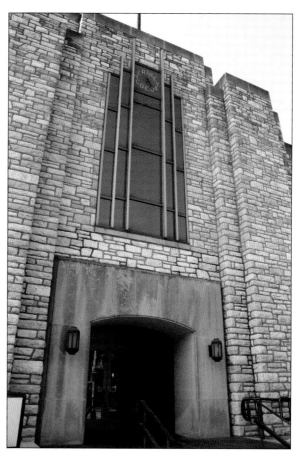

Hershey Kiss Street Lights, c. 1963. The Hershey Chocolate Company, c. 1903.

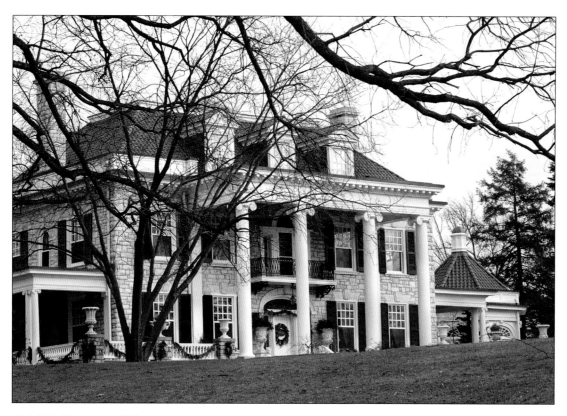

High Point Mansion, c. 1913.

THE HOTEL HERSHEY, 100 Hotel Road, Hershey: Established in 1933, this was one of the major construction jobs that Milton S. Hershey undertook to create jobs during the Great Depression.

The Hotel Hershey entrance sign.

Light post at The Hotel Hershey.

The Hotel Hershey, c. 1933.

HERSHEYPARK, 100 W. Hersheypark Drive: Designed by Oglesby Paul, Hershey Park was developed for community use in 1910. It offered a swimming pool, playground, a free zoo, daily concerts, bowling alley, and amusement rides. Milton S. Hershey donated the first roller coaster in honor of the town's twentieth anniversary in the 1920s. Hershey Park was renamed to "Hersheypark" in 1971 and developed as a theme park. For the first time, it was fenced in and an admission fee was charged.

Hersheypark, established in 1910.

THE HERSHEY COMMUNITY CENTER, 2 Chocolate Avenue: Built during the Great Depression, the building held a 58-bed hospital, classrooms, dorms, recreational facilities, library, cafeteria, and two theaters.

Hershey Community Building, c. 1933.

THE HERSHEY STORY: THE MUSEUM, located at 111 W. Chocolate Avenue: The museum contains the legacy of Milton S. Hershey and his generosity to others.

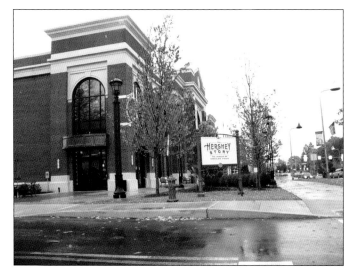

The Hershey Story: The Museum.

HERSHEY TRUST COMPANY, One W. Chocolate Avenue: The company was founded in 1905 by Milton S. Hershey.

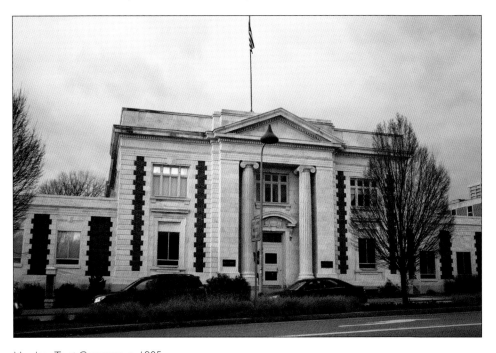

Hershey Trust Company, c. 1905.

The Press Building, c. 1915.

THE PRESS BUILDING, 27 W. Chocolate Avenue: Built around 1915, it served as the Press Building until becoming a department store in 1920. It is now home to Houlihan's Restaurant. Behind the building is a view of the Kissing Tower in Hersheypark.

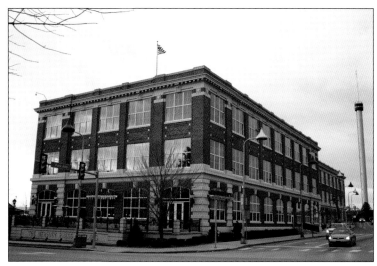

Camp Hill

The ancient name for the part of Cumberland County immediately west of Harrisburg was the Manor of Lowther containing 7,587 acres. It extended from the Susquehanna River west to Orr's Bridge Road, and from the Conodoguinet Creek south to the Yellow Breeches Creek. This area was originally intended by the Penn family to be an Indian Reservation with numerous bear, deer, and other game. Native Americans came to Pennsylvania in 1689 from Georgia and Carolina and occupied lands west of the Susquehanna on the Conodoguinet. There were Indian towns and wigwams on the banks of the Susquehanna River, and Yellow Breeches and Conodoguinet Creeks.

During William Penn's first visit to the Colony, he began the process of clearing the way for a white settlement beyond the Susquehanna River. On the west side of the Susquehanna River in the 1700s, Indians engaged in murdering whites and setting their homes on fire. Indians made complaints to the Colonial government of broken promises regarding land within the Manor. A special treaty was arranged in Carlisle in 1753 by Benjamin Franklin, Richard Peters, and Isaac Norris promising satisfaction for the Manor lands. Council voted to ignore the complaint. Franklin recorded in a notebook after the 1753 treaty that a drunken Shawnee conversed with him informally about the lands reserved for his tribe by the Proprietors, and the Shawnee wanted to sell the lands since they no longer needed them.

There were scalpings in the Manor of Lowther until 1757. Thomas Penn appointed Indian Chief Peter Chartier to advise the Indians in 1729 regarding permission to trade across the Susquehanna. Chartier remained in the Manor area until 1744, conducting his trading business. The oldest structure was built in 1772 at 19th and Market Streets. St. Johns Road was once an Indian path leading south from the Conodoguinet. Thomas Penn was the father of the Manor, with the first warrant (deed) granted in 1767. The Manor was divided into plantations of about two hundred acres. The Penns had two tracts of land reserved for them (most of the territory between Country Club Road and Orr's Bridge Road), but no evidence was found of the family ever residing here. The first settlers typically lived in cabins of wood or log, and later erected larger houses, often of limestone. The Germans constructed

Conodoguinet Creek at Orr's Bridge. Reflection of fall foliage and buildings at top of the hill on Market Street.

their homes very close to the road while English settlers set their houses back a substantial distance from the road. Until 1870, owners in the Manor of Lowther paid sums of annual quit rents (land tax) to the Penn family. On October 4, 1794, President George Washington passed through the Manor on his way to Carlisle.

In 1820, there were eight structures between current day 19th and 31st Streets. This village was previously known as Oyster's Point, Walnut's Grove, and White Hall before being incorporated as the Borough of Camp Hill on November 10, 1885.

On a foggy night in 1862, a Pennsylvania Zouave regiment was tenting in forts that linked the Conodoguinet and Yellow Breeches Creeks. There were fifty-eight casualties when a Cumberland Valley Railroad train plowed into a shifting engine.

The eyes of the nation focused on the Camp Hill area in June 1863 during the Civil War, as it was believed that Harrisburg was the main target to be overtaken by Confederate soldiers. On June 10, 1863, a new Susquehanna Military Department was created by the War Department with boundaries from the peak of the Alleghenies at Johnstown eastward to the Delaware River. Major General Darius Nash Couch, a West Pointer, was appointed commander. Couch conferred with Governor Andrew G. Curtin on June 11th and departed for Chambersburg to establish a field headquarters because of the presumed Confederate invasion route. Couch chose to defend Harrisburg from the West Shore. Fort Washington was built to overlook the capital city on the high land to deny invaders access to the Camel Back Bridge and Cumberland Valley Railroad Bridge. Diggers used hand tools in working on Fort Washington, named after the first President. There was at least one casualty when Louis Drexler plunged sixty feet to his death. Couch later ordered units into Perry County to man defenses that had been dug at the two railroad bridges spanning the Susquehanna River at Marysville.

Residents in and around Camp Hill fled around June 22, 1863, because it was evident the great battle would be fought at or near Harrisburg. The invasion on the West Shore in Camp Hill occurred June 28-30, 1863, just three days before the Battle of Gettysburg. A line was formed on Sporting Hill, where Rebel guns opened on Union Captain Elihu Spencer Miller's unit from a distance so great they produced no effect. The Confederate artillery stood near the Salem Methodist Church. About eight hundred Confederates and four cannons were placed at Peace Church on Trindle Road. After several hours, and sporadic firing until dusk, the Battery withdrew, going west for the night. Lieutenant

Herman Schuricht's 14th Virginia Regiment viewed the city of Harrisburg and its defenses, the farthest Confederate advance. A picture, used by Currier & Ives and entitled *Cumberland Valley*, was taken during the 1863 invasion of the encampment on the hill by Fort Washington.

On June 28, 1863, Captain Miller and four companies from the 71st withdrew east within picket lines near Oyster Point, just east of present day 32nd Street. The Griffin Battery followed down the turnpike as far as 36th Street, where it was forced off the road because of a blockade erected. On June 29, 1863, the defending picket line ran across the Manor of Lowther from high ground at modern day 21st Street to White Hill and along Lisburn Road toward the Yellow Breeches Creek. Confederate Brig. General Albert G. Jenkins set up a fierce clamor with artillery, and firing lasted two hours. Advances were made down the Turnpike and Trindle Spring Road, shooting in many directions. There was at least one shot as far as the Church of God on 21st Street.

On June 28, 1863, General Lee countermanded his order to Confederate General Richard S. Ewell and directed the Corps toward a small Adams County town. This changed the great battle of war from Camp Hill to Gettysburg. The windows of the homes of Camp Hill residents shook from the cannonading at Gettysburg.

Near present day Park Inn, sixteen Confederates were killed at Sporting Hill on June 30, 1863, when Union forces surprised them. By June 30th, all of the forces, save for Jenkins' Brigade, had proceeded south.

On July 1-2, 1863, it was noted by Martin Brinton that many Rebels were at Sherban place, present-day 4000 Market Street, believed to have been the Rebel picket line. That evening James Orr and Nicholas Eslinger were taken prisoner by the Rebels for one night. Mr. James Orr lived across the creek at the bridge while Nicholas Eslinger lived at the foot of the hill.

Zacheus Bowman reported seeing Jenkins and some of his men at the spring at Orr's Bridge. The artillery was on the pike below Orr's Bridge. The Rebels moved the cannon from Orr's Bridge towards the east.

Local soldier W.H.H. Smith related that while home on furlough June to July of 1863, the Rebels captured him and took him up the pike by the Sherban farm on the hill above Orr's Bridge and onto the headquarters of Confederate General Jenkins (Jonas Rupp House). Smith was released by Jenkins himself.

The Camp Hill Shopping Center is on the site of the Samuel Shopp farm, where Shopp saw a gable

of his barn knocked out by Rebels shooting at Union pickets.

A barn built in 1847 by George Barber is now part of Lower Allen Community Park. It was once part of a two hundred-acre farm that stemmed from a land grant from the heirs of William Penn. The land was farmed until 1963.

Other interesting facts about Camp Hill are:

• Coy Wire, a Cedar Cliff High School graduate, played professional football for the Buffalo Bills from 2002-2007 and the Atlanta Falcons in 2008 while Kyle Brady, another Cedar Cliff graduate, helped lead his Penn State football team to a championship with a Rose Bowl victory in 1994. He was chosen by the New York Jets as a first round pick of the NFL draft in 1995. He also played for the Jacksonville Jaguars and New England Patriots until retiring in 2008. In 2009, he was hired by the Big Ten Network as a football analyst.

• The romantic comedy film, *Mannequin*, starring Andrew McCarthy and Kim Cattrall, filmed scenes in the new Boscov's store in Camp Hill in 1987 before it was opened to the public. The scenes included McCarthy running up and down the steps in the Illustra store. Other portions of the movie were filmed in Philadelphia in the former John Wannamaker's Building that was built in 1861.

• The Oyster Mill Playhouse, Oyster Mill Road, Camp Hill, offers eight productions a year. In 1988, the 1820s rustic mill was converted into the current-day 91-seat theater.

Historic Peace Church

Also known as Friedens Kirch, the 2½-story limestone is located along Route 641 at St. John's and Trindle Roads. The congregation was formed in 1793 by a group of Reform German farmers who worshiped in their homes. Construction began in 1798, with completion and dedication on May 19, 1799. It was constructed by two well-known area artisans: Thomas Anderson, a mason, and Martin Rupp, a carpenter. Churches in eighteenth century Cumberland County resembled limestone homes built in the period. It was used for services by the Reformed and Lutheran congregations, and served as the mother church of all churches in the Harrisburg-West Shore area. The Doll Organ, believed to be the first of its kind in Cumberland County, was purchased in 1807. It is one of the few organs that still remains and is played in its original location in the U.S. It has a wine-glass pulpit, a wooden floor around the pulpit, and brick floor in the area of the pews. A balcony with pews is supported by pillars and extends around three sides of the interior. This landmark has remained completely unaltered. It was acquired by the Commonwealth of Pennsylvania in 1969, and is on the National Register of Historic Places. During the Civil War, farmers Lewis Bricker and Levi Balmer were locked in the church for one night on June 28, 1863. Today it is open for weddings and special services.

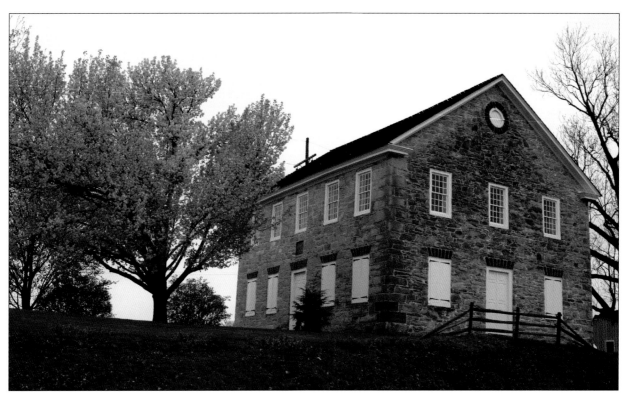

Historic Peace Church, c. 1798.

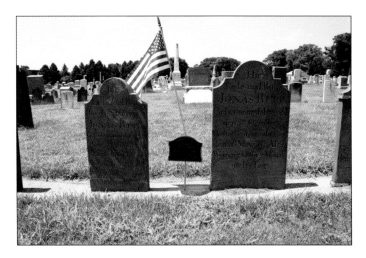

Top: The grave of Jonas Rupp, a Revolutionary War Patriot, in the cemetery at Peace Church. Above: The garden at Peace Church.

CAMP HILL CHURCH OF GOD, 123 N. 21st Street: The oldest church in the borough, the congregation dates back to 1833, with the stone building erected in 1849. During the Civil War in June 1863, it was said that shots were laid into several road barricades as far as this location.

Camp Hill Church of God, c. 1833.

Camp Hill Landmarks

THE HISTORIC WHITEHILL HOUSE, 1903 Market Street: Today it is the Myers-Harner Funeral Home. In 1771, Robert Whitehill took out a warrant for 213 acres and built the house shortly thereafter. In 1789, he purchased an adjoining 227 acres. In 1793, he was assessed with a two-story stone house, four hundred acres, two slaves, and a plate. Whitehill was prominent in politics during the Revolution and at constitutional conventions. He was influential in the formation and adoption of the Federal Bill of Rights. He is buried at Silver Spring Presbyterian Church. The land was later sold to Jacob Heyd, who was instrumental in making Camp Hill a borough in 1885; Heyd laid out 190 lots in 1891.

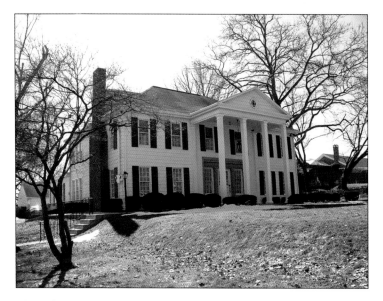

Historic Whitehill House, c. 1771.

SALEM CHURCH, Carlisle Pike, Mechanicsburg: Now known as Hope United Methodist Church, this stone structure was built circa 1818 on the Stayman farm. Confederate soldiers fired from the churchyard in 1863 just before the Battle of Gettysburg, under Colonel M. J. Ferguson of the 14th Virginia Regiment. The distance was so great they produced no effect on Captain Elihu Spencer Miller's unit. The chapel is still used for special occasions.

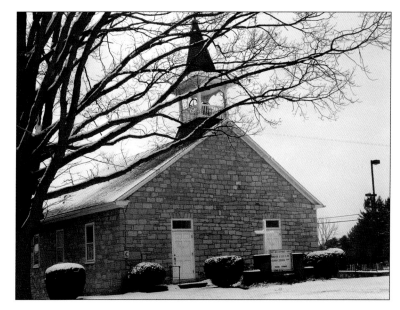

Salem Church, c. 1818.

THE JOHN BOWMAN TAVERN, 2602 Market Street: This two-story limestone was built on land that was warranted to Philip Kimmel in 1771. It had been the site of Tobias Hendricks Tavern operated from 1762.

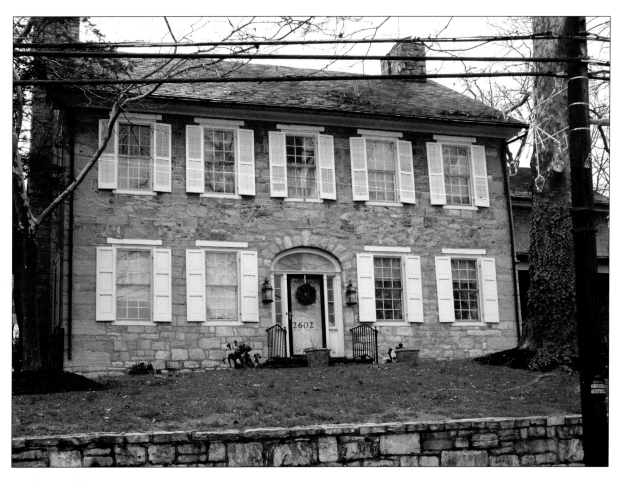

John Bowman Tavern.

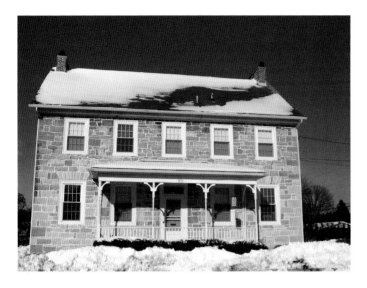

Andrew Moore House, c. pre-1798.

THE ANDREW MOORE HOUSE, 50 N. 36th Street: This two-story limestone Georgian style home was built pre-1798. It was originally a farmhouse built on Lot No. 22 of Manor of Lowther. Originally reserved for the Penn Family, it was later sold to a Penn family retainer, Edward Physick.

THE HISTORIC DANIEL SHERBAN HOUSE, 4000 Market Street: Currently the law offices of Foulkrod Ellis, this Federal style 2½-story limestone house was built around 1798 when owned by Edward Morton. The land to the farmhouse, Lot No. 24 in the Manor of Lowther, originally contained 304 acres. The house was colonialized during the twentieth century when a two-story frame addition was built on the east wall, a portico added, and a bay window created at the rear. Daniel Sherban acquired the property in 1812. The land of the original property is believed to have been connected to the Peace Church property. There were at one time references to Indian huts or cabins on this property, and it could have had some structures as early as 1736. The Rebel picket line was reportedly at the Sherban farm during the Civil War.

An English-tudor style building is just west of the Daniel Sherban House. It is home to various offices. The stone portion of the building is believed to have been the foundation of the former barn that was on the original property of the Daniel Sherban plantation.

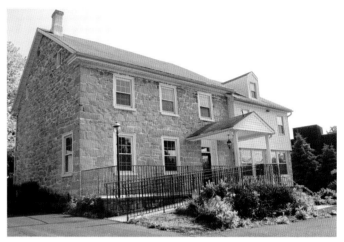

Daniel Sherban House, c. 1798.

English Tudor style building.

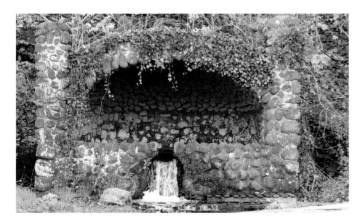

Stone Spring on Orr's Bridge Road.

STONE SPRING, Orr's Bridge Road, near Carlisle Pike: During the Civil War, there were reports of Jenkins and some of his men at this spring. Nearby Orr's Bridge was built in 1834-1835 and named after James Orr, who contributed largely toward the bridge.

Mechanicsburg

Situated eight miles west of Harrisburg, this town was settled in 1806 and incorporated as a borough in 1828. It was named for a settlement of mechanics that made and repaired covered wagons in the early 1800s. Lumberyards, grain and feed companies, and factories were built along the Cumberland Valley Railroad, where at one time there were twenty-five trains daily carrying travelers, newspapers, ice, mail, coal, fruit, and feathers. During the Civil War, the railroad was utilized for transporting supplies and troops. The town previously was known as Drytown, Pinchgut, Staufferstown, and Creekville.

On June 28, 1863, Confederate Brig. General Albert G. Jenkins was marshalling two regiments, preparing to pounce on Mechanicsburg. Jenkins rode into town under a flag of truce. After shaking hands with a militia cavalry commander, he asked Mechanicsburg for 1,500 rations. Within a few hours, the citizens of Mechanicsburg were piling 1,500 rations at a collection point. After pulling down the Stars and Stripes and positioning his command one mile east of town, Jenkins returned to the Ashland House near the CVRR Depot. Two miles east militia sentries in a church steeple over Shiremanstown spotted the arrival of the Southern cavalry and rang the bells in alarm.

In late June 1863, Mechanicsburg was captured as Confederate Troops were approaching Harrisburg. The Confederates were met by Union forces in the Skirmish of Sporting Hill, known as the northernmost engagement of the Civil War. The Confederates then retreated south to Gettysburg.

Other interesting facts about Mechanicsburg:

• It was home to the first Pennsylvania women's college to grant degrees in arts and sciences. Irving Female College was established in 1856, and was named for its trustee, Washington Irving. It no longer exists; however, the building still stands at the eastern end of Mechanicsburg on Trindle Road.

• In the 1890s, the Great Grangers' Interstate Picnic Exhibition was held on Williams Grove Road with 100,000 in attendance. The John Williams House, which is nearby, was built in 1799.

• In 1909, Messiah College was founded in Mechanicsburg. This Christian-oriented college is well-known for its sports teams, many of which have won national titles.

• The Naval Supply Depot, built in 1941, and the Williams Grove Speedway, attracting sprint and late-model drivers from all over the country, are both located here.

• Mechanicsburg was the location for portions of two famous films. Eckel's Drugstore along Main Street was featured in scenes from *Girl Interrupted* in 1999 with actors Angelina Jolie, Winona Ryder, and Whoopi Goldberg. The old-fashioned drug store gave the film its time-dated appearance from April 1967. Denny's Restaurant, along the Carlisle Pike, was a film location for *Lucky Numbers*, starring John Travolta and Lisa Kudrow.

• Jubilee Day, formerly Farmer's and Merchant's Day, has been held here annually on the third Thursday in June since 1923. It is one of the largest and longest-running one-day street fairs on the East Coast.

• The unique stores of Civil War and More and The Rosemary House can be visited at 10 S. Market Street and 120 S. Market Street, respectively.

Poison, a 1980s glam metal band, is from the Mechanicsburg area. It features band member, Bret Michaels, who has also appeared on television in *Rock of Love with Bret Michaels*, *Nashville Star* as a judge, and *Celebrity Apprentice 3*, which he won.

Jonas Rupp House

This 2½-story limestone home at 5115 East Trindle Road was built in the eighteenth century by Jonas Rupp. The first portion was built in 1773 and the second portion in 1787 on property that once contained 280 acres. The Rupp family helped to build many buildings and churches: Silver Spring for Scotts-Irish and Trindle Spring, Poplar Grove, and Peace Church for Germans. Rupp conducted prayer meetings in his home. Jonas Rupp was a German immigrant, leader of the early German Reformed Church, and a Revolutionary War supporter.

When Jonas Rupp arrived on the ship *Phoenix* on September 25, 1751, his personal effects were stolen; penniless, he was a Redemption servant for two years and six months near Lebanon. Of the 412 people who embarked on the same vessel, only 180 survived. Many of the Redemption servants served their time faithfully and became some of the most wealthy and influential citizens of the state. Jonas Rupp responded to George Washington's call to aid in the Whiskey Rebellion. He is buried in the cemetery at Peace Church. The property was then acquired by his son, Martin Rupp, a well-known cabinet maker.

During the Civil War, this home was raided and used as Confederate Headquarters by General Albert Jenkins of the Confederate Army, just days before the Battle of Gettysburg. The Battle of Sporting Hill, in which these troops were engaged, took place on June 29, 1863. They were fighting to take Harrisburg and cross the Susquehanna River.

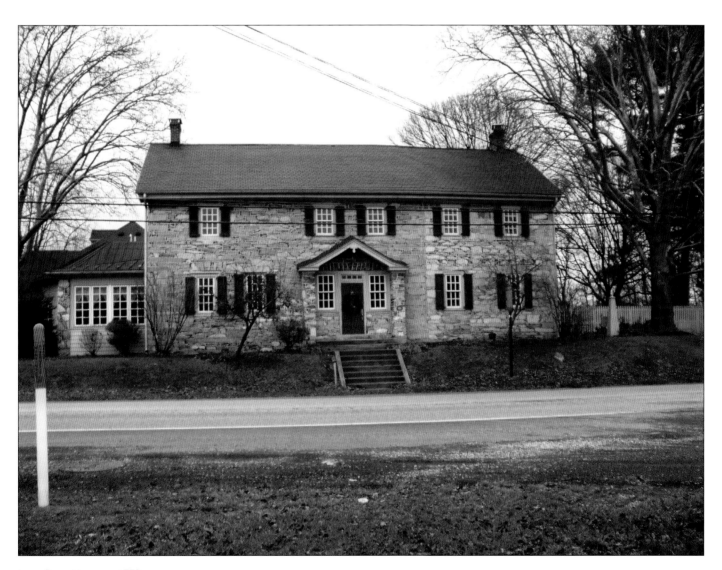

Jonas Rupp House, c. 1773.

Mechanicsburg Landmarks

HOUSTON MILL, Willow Mill Park Road: The 2½-story limestone was built in 1795 and was then known as the John Walker Mill. It was part of the Willow Mill Amusement Park from the 1950s to 1989, and is one of three remaining mills in the county. Plans are underway to restore the historic mill.

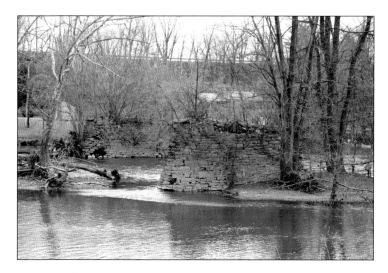

Remnants of piers in the Conodoguinet Creek were used to support a covered bridge.

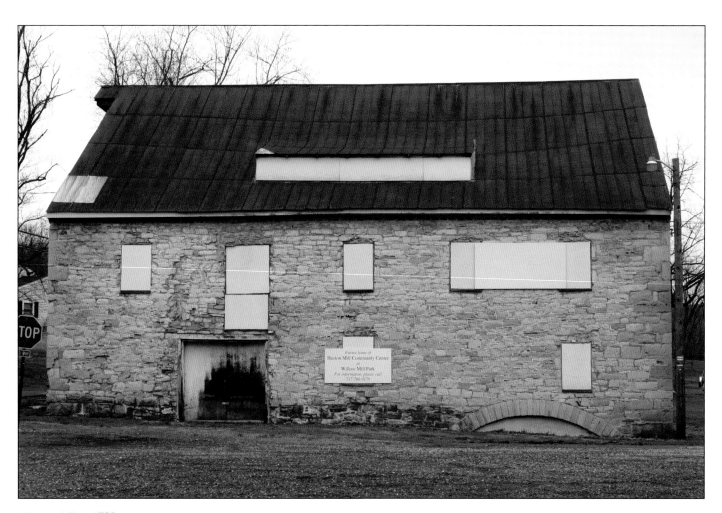

Houston Mill, c. 1795.

FRANKENBERGER TAVERN, 217 E. Main Street: Built in 1801 by George Frankenberger, it is the oldest building in Mechanicsburg. The log home was built as a tavern and rest stop for wagons and drivers traveling across the state. At that time, many traveled for two days from Harrisburg to Carlisle. Legend has it that a man who stayed here was robbed and murdered after bragging of the gold he was carrying from his sale of livestock. It is now owned by the Mechanicsburg Museum Association and is open on Saturdays from May through October.

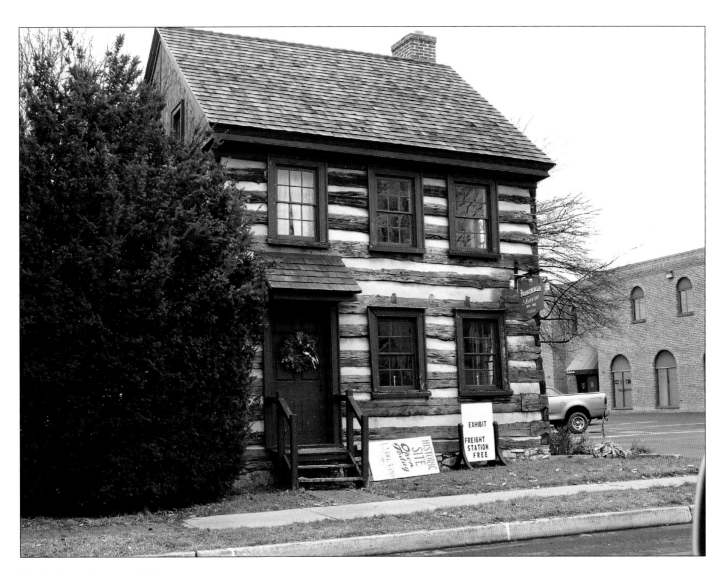

Frankenberger Tavern, c. 1801.

UNION CHURCH, East Main Street: Built in 1825, it is the oldest public building in Mechanicsburg. The land was given to the church by Martin Rupp. Many other congregations have used this non-denominational church as a meeting place.

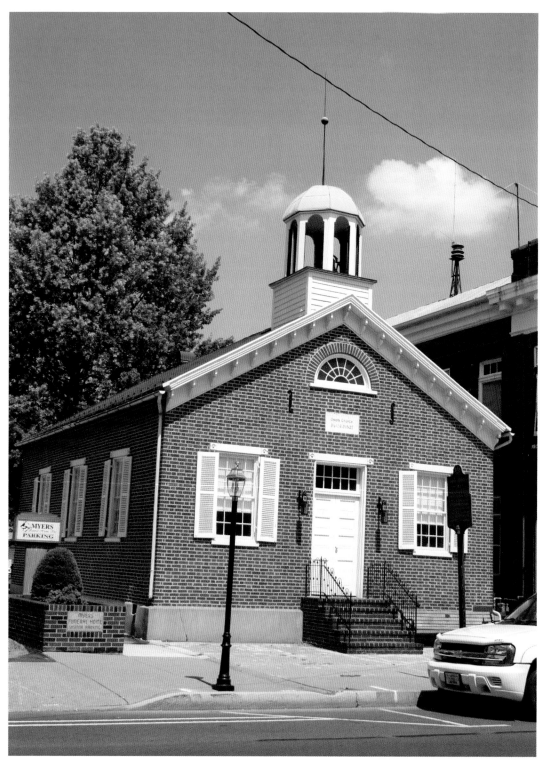

Union Church, c. 1825.

STATIONMASTER'S HOUSE, 4 West Strawberry Alley: Built in 1863, it was built for the town's stationmaster and his family by the Cumberland Valley Railroad Company. It was also used as the location of the borough's offices. Now owned by the Mechanicsburg Museum Association, it is open year-round Wednesday through Saturday.

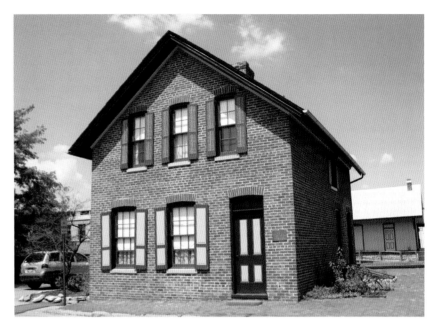

Stationmaster's House, c. 1863.

PASSENGER STATION, 2 West Strawberry Alley: Built in 1867, it is on the National Register for Historic Places. It is now the headquarters for the Mechanicsburg Museum Association and is open year-round Wednesday through Saturday. Exhibits display the history of the Cumberland Valley Railroad, as well as the town.

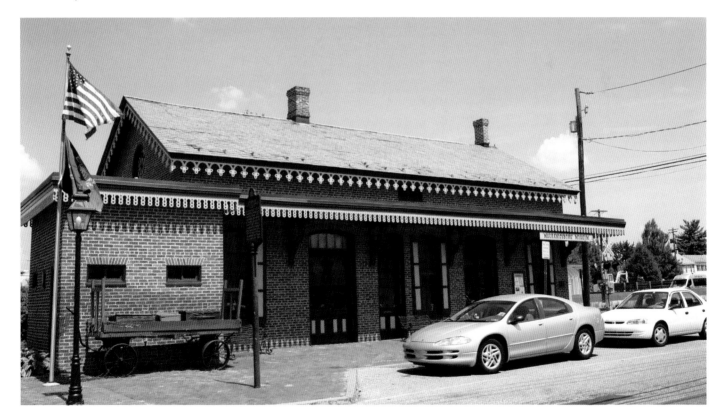

Passenger Station, c. 1867.

Joseph T. Simpson Public Library, 16 N. Walnut Street: Built circa 1840, the building was noted to be a grain store and warehouse in the 1800s. On June 28, 1863, Confederate soldiers occupied the town for three days and used this building as a hospital for sick and ailing soldiers. The library purchased the building in April 1994.

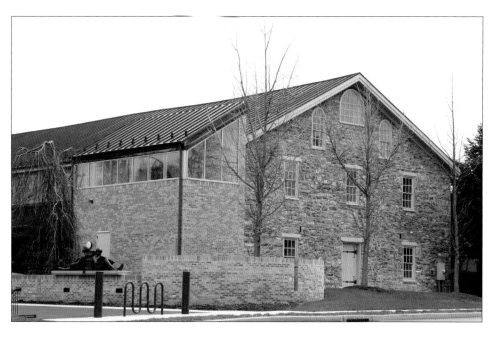

Joseph T. Simpson Public Library, c. 1840.

John Hoover House, 403 West Main Street: Built circa 1874, the land was purchased from John Hoover and the house constructed for Calvin Clendenin, owner of the largest tannery in Cumberland County. The Hexagonal Tower Victorian style brick home once contained a carriage house in the rear of the property that has since been converted to a residence.

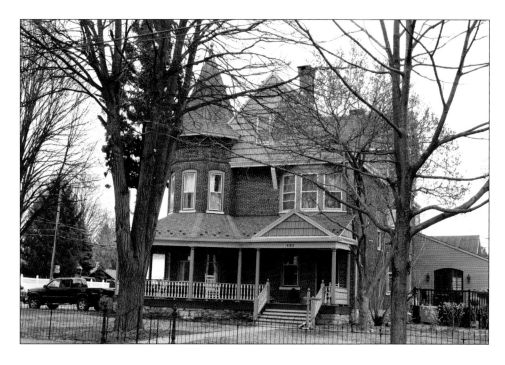

John Hoover House, c. 1874.

SILVER SPRING PRESBYTERIAN CHURCH, 444 Silver Spring Road: Built in 1783, it was founded in 1734 by Scotts-Irish Presbyterians on the land of James Silver. It was restored in 1928 and is still used for worship. The cemetery contains graves of numerous Revolutionary War heroes. (Below and next two pages)

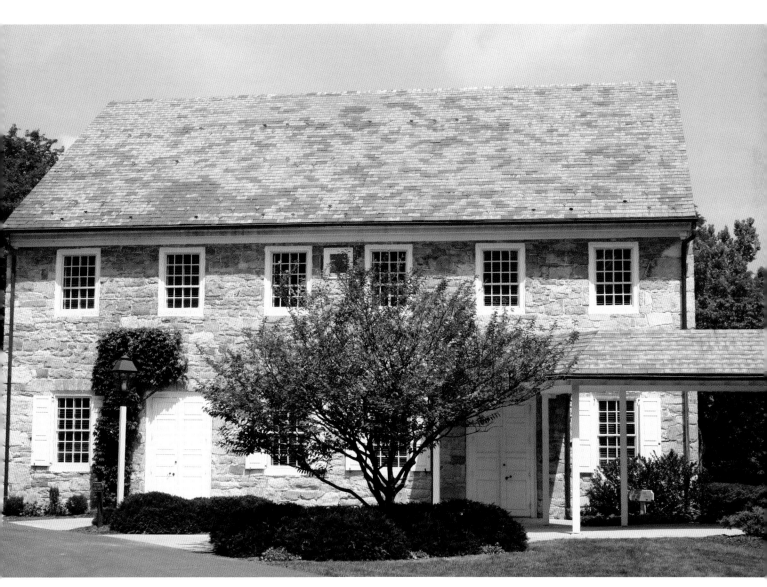

Silver Spring Presbyterian Church, c. 1783.

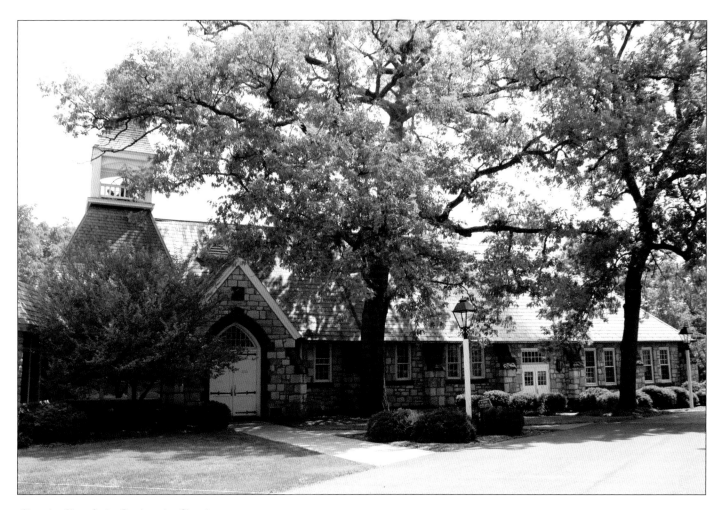

Chapel at Silver Spring Presbyterian Church.

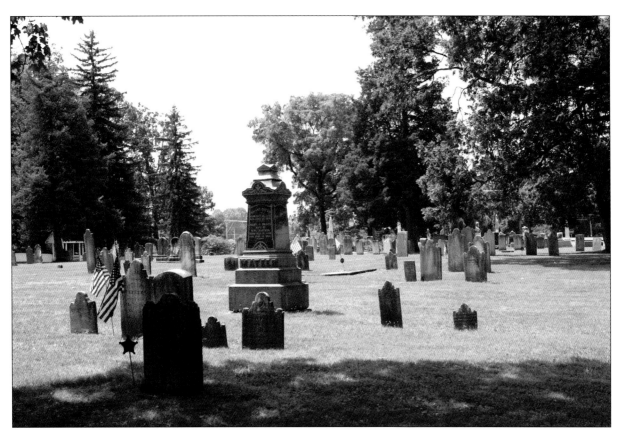
Revolutionary graves at Silver Spring Presbyterian Church.

Entrance to cemetery at Silver Spring Presbyterian Church.

Boiling Springs

The charming village of Boiling Springs started as an eighteenth century iron industry settlement. It became a village and recreational area in the nineteenth century. Between 1895-1930, it was known for its lake, amusements, and picnic grounds. The lake was man-made in the 1750s when springs were dammed to power bellows for the iron furnace. The dam also provided electricity for the village and power for the forge and grist mill. At the south end of the lake, at the edge of the parking lot, is the iron furnace stack used to manufacture tools from 1750-1882. The iron furnace was founded by John Rigbie & Co.

A small cluster of springs are located behind the Boiling Springs Tavern surrounded by a stone wall. From some openings in the limestone, water rises twelve inches above the surface and appears to be boiling. It is from this that the town acquired its name.

The bubble is part of an underwater spring system, and it is one of the natural springs that feed the Children's Lake. Subterranean caves 1,800 feet below the surface supply the lake with one-third of its water supply. The water temperature at the bubble is around fifty-two degrees.

Daniel Kaufman founded Boiling Springs. As an agent on the Underground Railroad, he was involved in a lawsuit filed by a Maryland slave-owner for reimbursement of thirteen slaves he lost. In the 1800s, Island Grove, in the Yellow Breeches Creek, provided a hiding place for slaves on the Underground Railroad.

Boiling Springs has been listed on the National Register of Historic Places since 1984, with a Historic District designated to include Front, Fourth, High, and First Streets.

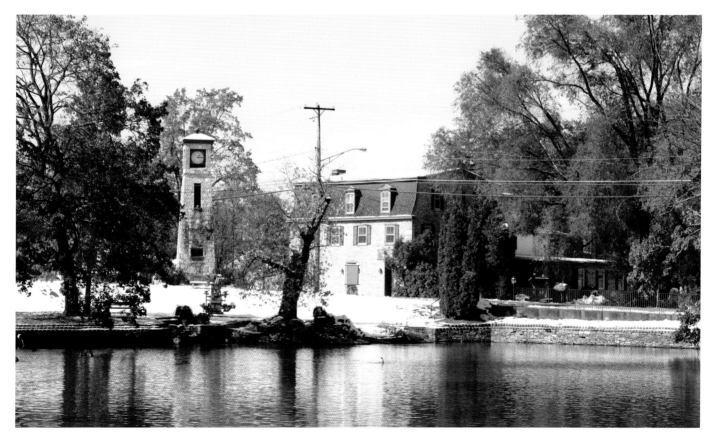

Children's Lake with view of Clock Tower and Boiling Springs Tavern.

The Appalachian Trail runs through the town. The stone wall around the lake was built in 1872 when owned by Carry Ahl, son of eminent Newville physician, Dr. John Ahl. In 1987, the lake was secured for public use and renamed "Children's Lake." Three engines to the railroad were named after the Ahl family. The railroad was completed to Boiling Springs in 1874. Boiling Springs was designated as the tenth Appalachian Trail Community.

Fishermen from all over the world fish in the famous Yellow Breeches Creek, which was once used to power grain and lumber mills. The watershed was used as an important shelter and checkpoint on the Underground Railroad. The creek begins near Walnut Bottom and flows through Cumberland County to the Susquehanna River.

The Boiling Springs Pool was built in 1927 on land owned by Jared C. Bucher. The tallest building was built in 1882 to house pumps for the Katherine Furnace. The 50' x 150' pool was built on the foundation of the Katherine Furnace. This was Cumberland County's first public swimming facility.

South Middleton was the first township to consolidate and close one-room schools in the county. The year 1951 marked the beginning of the Kindergarten program. A one-room school can be seen at Fourth and Walnut Streets.

The Appalachian Trail Conference Cottage was once a restaurant and store for the Boiling Springs Park, and the Yellow Breeches Outfitters was the site of a dance pavilion around 1900.

A Christmas Tree Lighting is held annually at Children's Lake. The Christmas Tree, floating in the center of the lake with luminaries placed on the wall around it, add ambience to this historic village.

The Foundry Day arts and crafts festival has been held annually since 1987 on the first Saturday in June with 15,000 to 20,000 in attendance.

Local artist, Gerald W. Putt, is a seven-time winner of the Pennsylvania Duck Stamp. His wildlife artist studio is located in Boiling Springs.

Boiling Springs Landmarks

CARLISLE IRON WORKS, just off Route 174: Founded by John Rigbie and Co. around 1762, this iron works was powered by water from the lake and Yellow Breeches Creek. During the Revolutionary War, munitions and ammunition were made here.

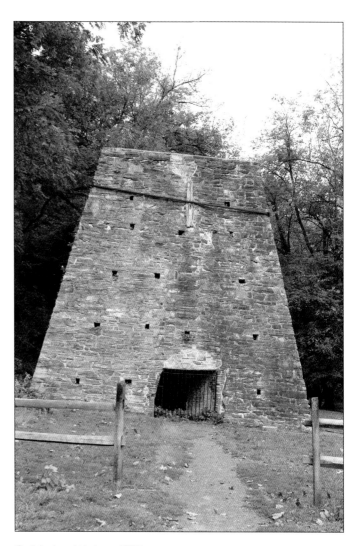

Carlisle Iron Works, c. 1762.

BOILING SPRINGS MILL, located at the lower end of the lake: Constructed around 1784 by Michael Ege to provide flour and grain for the iron works, the mill was originally a two-story structure. It was renovated in 1896 after a fire to its present 4½-story Colonial style. The two lower levels are made of native limestone with red sandstone quoins. It was converted to apartments when owned by the Bucher family. The mill was used as a setting for Hervey Allen's 1948 pre-Revolutionary novel, *Toward the Morning*.

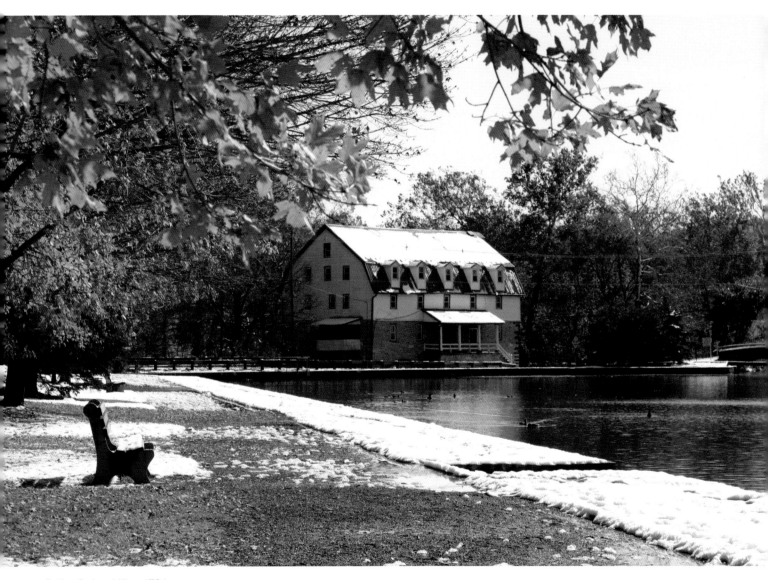

Boiling Springs Mill, c. 1784.

EGE MANSION HOUSE, located at the southeast side of the lake: Michael Ege, Sr. built the Federal style brick home around 1780. It was originally a 2½-story Georgian design. Ege was the ironmaster. The 23-room mansion overlooks the lake, has a three-story staircase, fireplaces, and fine architectural details. In 1798, it was the highest valued house in the county. It received substantial remodeling in 1880, and was colonialized in 1930. The mansion was a stop for slaves on the Underground Railroad when owned by Peter Ege, the last Ege to own the property. Jared C. Bucher purchased the mansion in 1887. His wife, Helen Hall Bucher, published the book, *Mountain Echoes*, that includes a poem she wrote about the house entitled "Highland House." The Bucher family owned the mansion until 1985. It was then a bed and breakfast. Ege Burial Plot, circa 1786, includes a solid iron doorway and iron door made at the furnace. Ege's Bridge, circa 1853-1854, crosses the Yellow Breeches Creek near the mill.

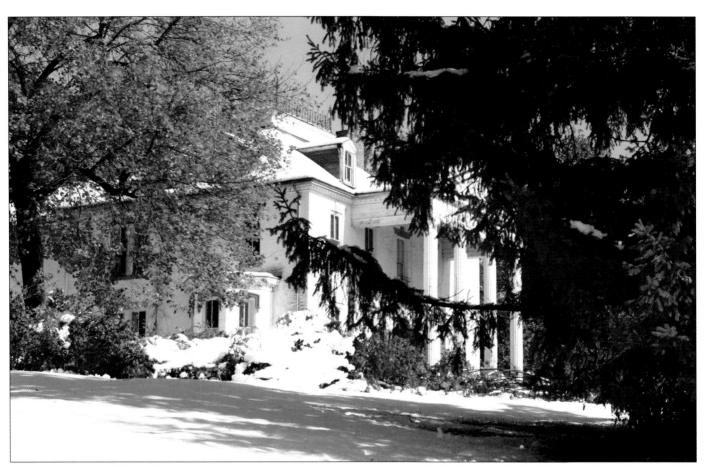

Ege Mansion House, c. 1780.

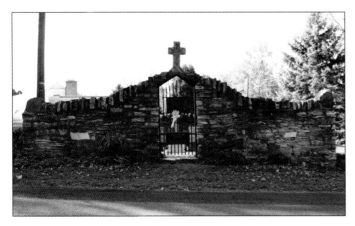

Ege Burial Plot, c. 1786.

Ege Bridge, c. 1853.

BOILING SPRINGS TAVERN, intersection of Forge Road and Old York Road: Built in 1832 by Philip Breckbill, the Federal style native sandstone was originally a hotel to provide food, drink, and lodging for travelers. It was also known as Breckbill's Tavern, The People's House, Filler's Hotel, Roberson's, and Anheuser-Busch. Today it is a popular fine-dining restaurant.

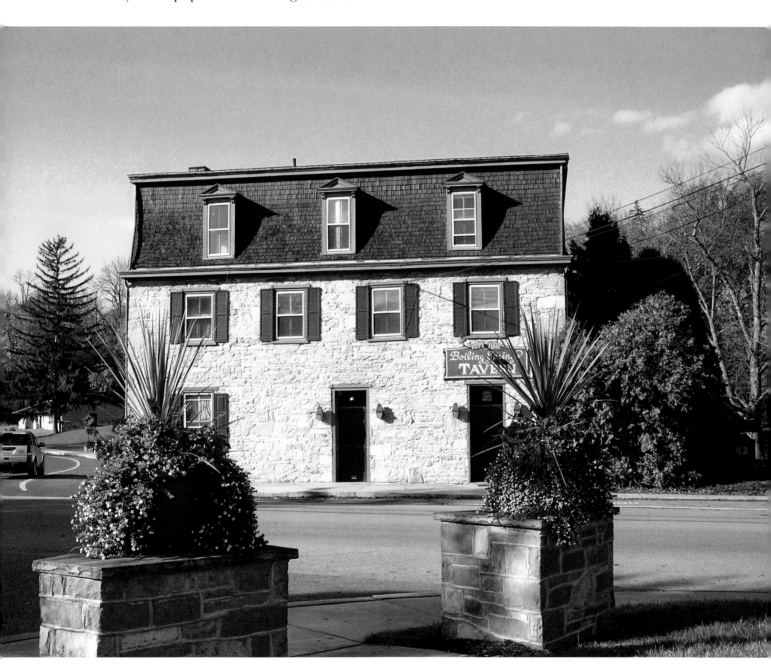

Boiling Springs Tavern, c. 1832.

MEMORIAL CLOCK TOWER, located just north of the lake: The 37-foot-high clock was dedicated on July 4, 1957, to all veterans of World Wars I and II. The limestone came from the Bucher barn that once housed slaves on the Underground Railroad operated by Daniel Kaufman, Stephen Weakley, and Phillip Breckbill. At the top is a four-faced clock with chimes. The naval cannon is from shipyards at Norfolk, Virginia. VFW Post 8851 built a small memorial in 1990 to honor veterans of the wars of Korea, Vietnam, Grenada, Panama, and the Persian Gulf.

Memorial Clock Tower, c. 1957.

LEIDICH'S STORE, 101 Front Street: This was the first lot sold in the village. In 1846, Adam Leidich built the common brick Federal style 2½-story structure and opened a general store. A post office and drug store were also located here. Adam Leidich laid out the village for Daniel Kaufman in 1845. This popular meeting place was referred to by residents at the Underground Railroad trial of Daniel Kaufman. Leidich was the first postmaster of Boiling Springs. Leidich hanged himself in his stable on June 17, 1895.

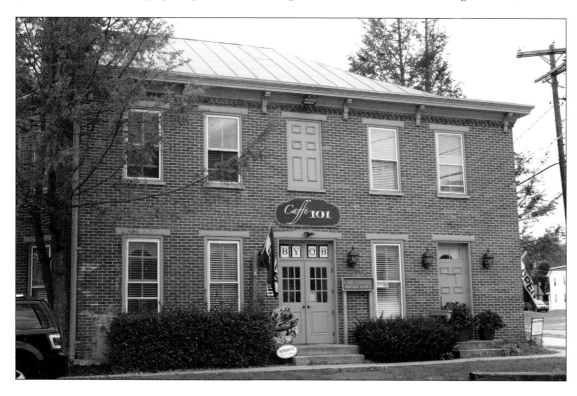

Leidich's Store, c. 1846.

Daniel Kaufman House, 301 Front Street: Built in 1880, the Federal Italianate style 2½-story common bond brick mansion belonged to Daniel Kaufman, founder of Boiling Springs and Underground Railroad agent. He assisted slaves (1837-1847) by hiding them at Island Grove just south of the Yellow Breeches. His Underground Railroad trial was held in 1848; he was found guilty and paid $5,000 in fines. Kaufman was a bitter enemy of Confederates, and upon learning of the Rebels passing through Mount Holly, he rode to the mountain and fired upon the Rebels. He is buried in Mount Zion Cemetery.

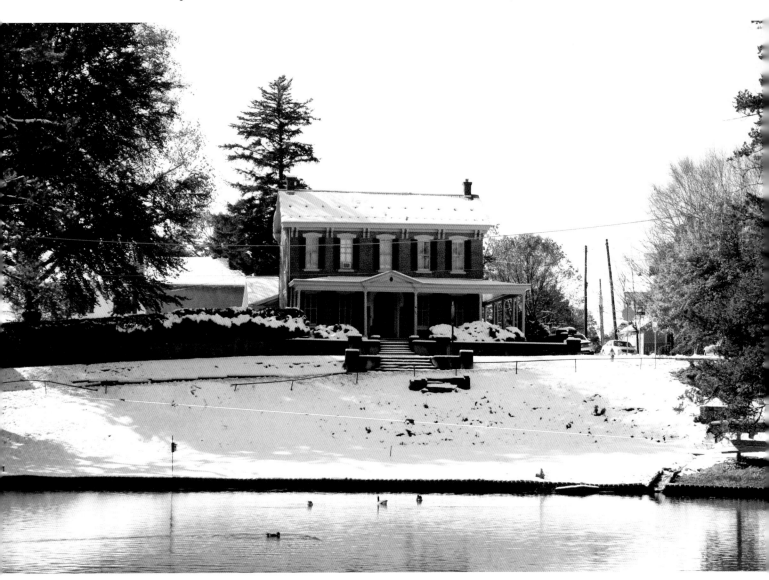

Daniel Kaufman House, c. 1880.

THE STONE HOUSE ON THE LAKE, 400 Front Street: Built between 1858-1872, the 2½-story native field stones to the house were said to have been used from other buildings that were demolished. The Gazebo was built in 1995. Mallard ducks enjoy Children's Lake. (Below and next page)

Stone House on the Lake, c. 1858.

Gazebo at Children's Lake, c. 1995.

Mallard Ducks at Children's Lake.

ALLENBERRY RESORT INN AND PLAYHOUSE, 1559 Boiling Springs Road: This country estate is located on fifty-seven wooded acres along the Yellow Breeches Creek. It was first developed as a private estate, and later the site of a family business providing recreation, relaxation, and respite. The Stone Lodge and Carriage Room were converted from a large stone barn built between 1812-1820.

In 1944, Charles A.B. Heinze and John W. Heinze bought the summer estate, and the year-round retreat was created with good food and comfortable rooms. The summer theater was started in 1949 with 420 seats. The theater season is currently open from March through December with professional casts performing Broadway productions.

Additional buildings include a lodge, swimming pool, tennis courts, the Undershoot, Beltzhoover Terrace, and lodging in the Pines.

The Yellow Breeches is a beautiful stream that is frequented by fishermen from all over the country. The colorful fall foliage can be seen in the reflection of the stream. The theater is open March through December. (Below and next three pages)

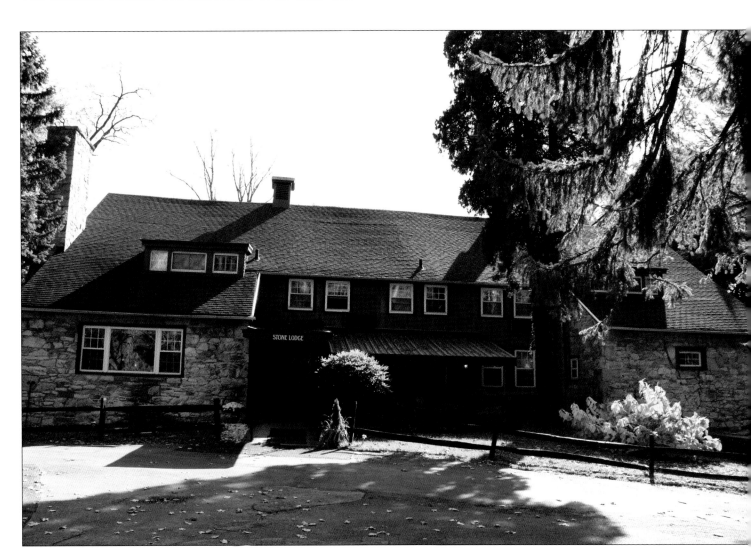

Stone Lodge and Carriage Room, c. 1812.

Allenberry Light Post surrounded by fall leaves and snow.

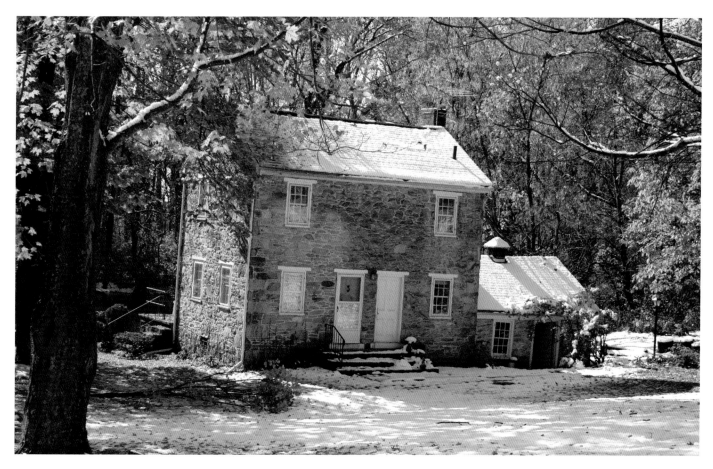

Still House, c. 1778. James Crockett built a very small dwelling consisting of a kitchen and two additional rooms on the banks of the Yellow Breeches, known as the Still House.

Allenberry Playhouse entrance.

Fall leaves at Yellow Breeches.

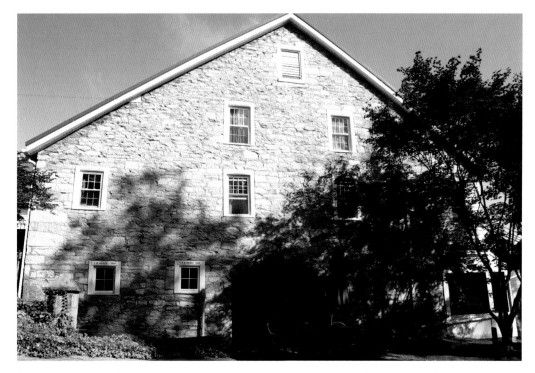

Fairfield Hall, c. 1778. James Crockett also built the large bank barn on the hillside that is now known as Fairfield Hall. The names of all owners can be seen listed above the windows on the outside wall.

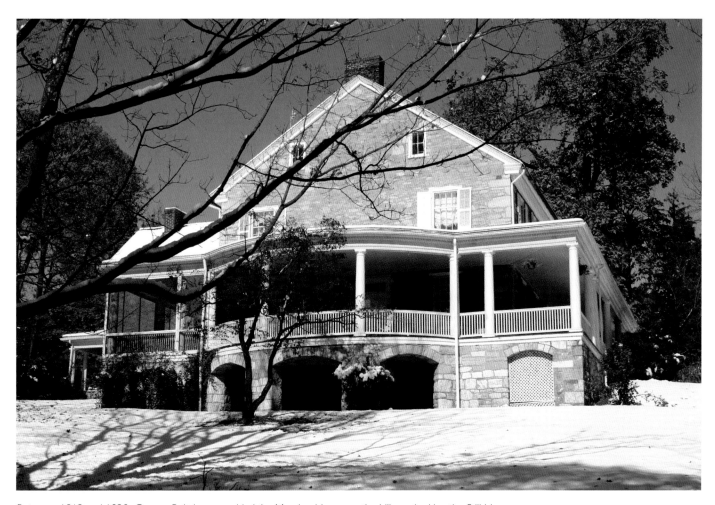

Between 1812 and 1820, George Beltzhoover added the Mansion House on the hill overlooking the Still House.

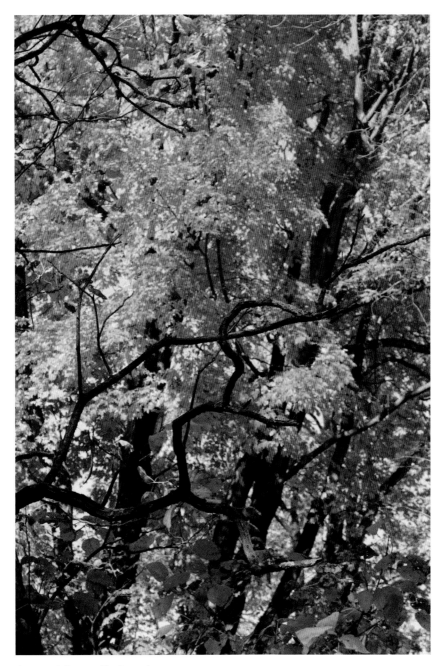

Autumn foliage at Allenberry Inn.

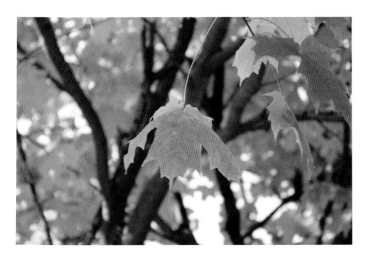

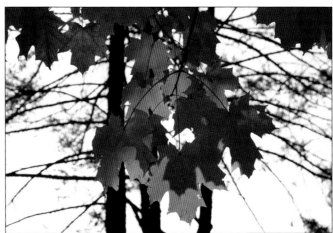

Bibliography

Archives and Manuscripts

Architectural Survey Forms, Cumberland County Historical Society (hereafter CCHS).

Atlas of Cumberland County, 1872. CCHS.

Chambersburg Heritage Center, Chambersburg, Pennsylvania, 2010.

Cumberland Valley Railroad Directory Harrisburg to Hagerstown, 1902. CCHS.

Deeds, Cumberland County Courthouse, Recorder of Deeds Office, 2009-2010.

Directory of Cumberland County, Dauphin County, Lebanon County, 1910-1912. CCHS.

Directory of Cumberland Valley Railroad Main Line Carlisle, Mechanicsburg, Newville, Shippensburg, 1906-1907. CCHS.

Directory of Cumberland Valley Railroad Main Line Harrisburg to Hagerstown, 1904-1905. CCHS.

Farm Journal Directory of Cumberland County, 1914-1915. CCHS.

Map of Cumberland County, 1858. CCHS.

Tax Lists, 1762-1847. CCHS.

The Hershey Story Collection and Photo Archives, Hershey, Pennsylvania, 2009.

Newspapers

The following were reviewed at the Cumberland County Historical Society.

Carlisle Gazette, 2005.
Herald, The, 1805-1863.
News-Chronicle, The, 2005-2006.
Sentinel, The, 2002-2011.
Valley Times-Star, The, 2009-2012.

Books, Articles, and Typescripts

Beckley, Gilbert W. *The Sampler from Seventy-Six*. Ann Arbor, Michigan: Edward Brothers, Inc. 1975.

Beetem, Charles Gilbert. *Colonial Carlisle*. Carlisle, Pennsylvania: Hamilton Library Association, 1958.

Bowman, Addison M. *Camp Hill in the Civil War Together with Narratives Relative to Confederate Invasion of Pennsylvania During the Civil War*. Camp Hill, Pennsylvania: Self-Published, 1927.

Breon, Stacy L. *The History of 4000 Market Street, Camp Hill, Pennsylvania*. Camp Hill, Pennsylvania: Self-Published, 2010.

Crist, Robert Grant. *Camp Hill, A History*. Camp Hill, Pennsylvania: R.G. Crist, 1984.

Confederate Invasion of the West Shore – 1863. Carlisle, Pennsylvania: CCHS, 1963.

Hamilton Library Assoc. Historical Papers Annual Report, Vol. 8 – Manor on the Market. Carlisle, PA: CCHS, 1967.

Peace Church. Camp Hill, Pennsylvania: Plank's Suburban Press: 1966.

The Land in Cumberland Called Lowther. Lemoyne, Pennsylvania: Lemoyne Trust Company, 1957.

Garrett, Clarke, Ph.D. *In Pursuit of Pleasure – Leisure in Nineteenth Century Cumberland County*. Carlisle, Pennsylvania: CCHS, 1997.

Houts, Mary Davidoff and Pamela Cassidy Whitenack. *Images of America – Hershey*. Charleston, South Carolina: Arcadia Publishing, 2000.

Keefer, Norman D. *A History of Mechanicsburg. Mechanicsburg, Pennsylvania*: Mechanicsburg Area Historical Committee, 1976.

Landis, Merkel, Esquire. *Civil War Times in Carlisle*. Carlisle, Pennsylvania: Hamilton Library Association, 1931.

Moll, Don. "A Spring, A Mill and A People." June 26, 1976. (Newville Historical Society, Newville, PA.)

Rupp, I. Daniel. *The History and Topography of Dauphin, Cumberland, Franklin, Bedford, Adams, and Perry Counties*. Lancaster City, Pennsylvania: Gilbert Hills, Proprietor & Publisher, 1846.

Schaumann, Merri Lou. *Taverns of Cumberland County*.

Lewisberry, Pennsylvania: W&M Printing, Inc., 1994.

Sloate, Susan. *The Secrets of Alcatraz*. New York, New York: Sterling Publishing Co., 2008.

Tritt, Richard L. and Randy Watts. *At a Place Called the Boiling Springs 1845-1995*. Boiling Springs, Pennsylvania: Boiling Springs Sesquicentennial Publications Committee, 1995; The Bubbler Foundation, 2002.

Wing, Rev. Conway P., DD. *History of Cumberland County, Pennsylvania, With Illustrations*. Philadelphia, Pennsylvania: James D. Scott, 1879; Carlisle, Pennsylvania: Herald Printing Company, 1982.

Zdinak, Paul. *Bessie's House*. Harrisburg, Pennsylvania: Your Private Printer, Inc., 1976, 1990.

Websites

Allenberry Resort Inn and Playhouse, information retrieved October 9, 2009 from the website: www.allenberry.com.

Big Spring Heritage, information retrieved October 12, 2009 from the website: www.bigspringheritage.org.

Borough of Carlisle, information retrieved October 9, 2009 from the website: www.carlislepa.org.

Carlisle House Bed & Breakfast, information retrieved October 30, 2009 from the website: www.thecarlislehouse.com.

Cumberland County, information retrieved October 30, 2009 from the website: www.ccpa.net.

Cumberland County Library System, information retrieved October 23, 2009 from the website: www.cumberlandcountylibraries.org.

Downtown Carlisle Association, information retrieved October 9, 2009 from the website: www.downtowncarlisle.org.

Ewing Brothers Funeral Home, information retrieved October 27, 2009 from the website: www.since1853.com.

Historic Peace Church, information retrieved October 30, 2009 from the website: www.historicpeacechurch.org.

Kings Gap, information retrieved October 9, 2009 from the website: www.visitPAparks.com.

150 Pennsylvania Civil War Anniversary from 2011-2015, information retrieved October 7, 2009 from the website: www.PACivilWar150.com.

The 18th Century Inn, information retrieved October 22, 2010 from the website: www.18thcenturyinn.com.

The U.S. Army Heritage and Education Center retrieved October 22, 2010 from the website: www.usahec.org.

Wikipedia, information retrieved December 12, 2009 from the website: www.wikipedia.org.

Index of Places